Dartmouth College Football
Green Fields of Autumn

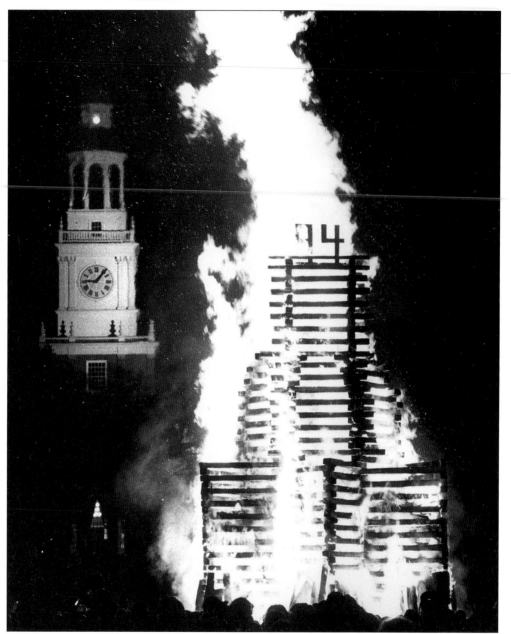

DARTMOUTH SPIRIT. The first bonfire on the Dartmouth Green celebrated a baseball victory in 1888. In the 1890s, bonfires became part of Dartmouth's football tradition, and there is no scene more magical than the crowd of several thousand students, alumni, and members of the community surrounding the towering pyre on an autumn Friday night of Homecoming Weekend in Hanover. For decades, bonfires were built with whatever materials the resourceful freshman class could scrounge to build and kindle the fire; one area farmer, according to legend, was obviously irate when his barn was torn down by mistake. Engineering students at Thayer School devised the construction pattern using railroad ties c. 1950. A six-pointed star base is topped by a hexagon, then a square. Until the mid-1980s, class numerals became the goal for the number of tiers. Safety concerns now cap the height at 80 tiers for the Dartmouth Night celebration.

THE BALLOON MAN. Frank DelVecchio first drove north from Boston to Hanover in 1930 to sell balloons, pennants, and pins to Dartmouth's football faithful. He said, "It was love at first sight. I never went to college, so I decided to make this my college." For more than a half-century, until the early 1980s, DelVecchio was a football weekend fixture in Hanover, greeting fans and friends from the back of his station wagon near the Hanover Inn and always taking time to hug the children and wink at the college women. "Balloons are beautiful things," he said. "Whether you're young or old, they've got some kind of magic." He once offered a $200 prize (which he said was "for tuition, not for beer") to the Dartmouth student who wrote the best essay about balloons. Sever Peters '54, the director of athletics from 1967 to 1983, encouraged his classmates to make DelVecchio an honorary class member. All of this proves that at Dartmouth, on the football field and off, tradition can never be overinflated.

Terrific Tandem. From 2000 to 2003, Dartmouth had one of the Ivy League's most dangerous passing attacks with tight end Casey Cramer '04 (82) and wide receiver Jay Barnard '04 (88). Over four seasons, Cramer, who was drafted in 2004 by Tampa Bay as a fullback-tight end, caught 185 passes for 2,477 yards and 21 touchdowns (a Green record). Barnard made a record 216 catches for 2,392 yards. During the 2003 season, as Dartmouth won five of its last six games to finish 5-5-0, its best record since 1997, Barnard (70 catches, 861 yards, 5 touchdowns) and Cramer (58 catches, 695 yards, 6 touchdowns) accounted for 1,556 of Dartmouth's 2,404 yards gained by passing. No team in Dartmouth history had such a prolific receiving combination.

Dartmouth College Football
Green Fields of Autumn

David Shribman and Jack DeGange

ARCADIA

First published 2004

Published by Arcadia Publishing,
Charleston SC, Chicago IL, Portsmouth NH, San Francisco CA

Printed in Great Britain

Library of Congress Catalog Card Number: 2004103634

For all general information, contact Arcadia Publishing:
Telephone 843-853-2070
Fax 843-853-0044
E-mail sales@arcadiapublishing.com
For customer service and orders:
Toll-free 1-888-313-2665

Visit us on the Internet at www.arcadiapublishing.com

Front cover, left: Andrew Hall's remarkable catch of Charlie Rittgers's 38-yard pass on 3rd-and-28 in the fourth period against Harvard was *the* play of the 2003 season for Dartmouth. Hall's catch put the ball at Harvard's two-yard line and set up the clinching touchdown in Dartmouth's 30-16 upset win. (Photograph by Kathy Slattery.)

Front cover, right: Two-time All-Ivy quarterback Jim Chasey confers with coach Bob Blackman during Dartmouth's undefeated season in 1970.

Back cover: A crowd of 20,336 jams Memorial Field in Hanover to watch the Harvard-Dartmouth game on October 16, 1976.

CONTENTS

ACKNOWLEDGMENTS

This portrayal of 122 seasons of Dartmouth College football, from 1881 through 2003, acknowledges the several thousand Dartmouth men who have represented Dartmouth on the gridiron, their coaches, and many others who have played supporting roles—all of whom have contributed to this story of achievement and tradition.

Producing this story has been accomplished with the benefit of unlimited access to photographic images and reference material retained by the Dartmouth College Athletic Department (DCAD) and the Rauner Special Collections Library at Dartmouth College. All images in this book come from these two resources. Where appropriate, specific photograph credit is noted.

First, we wish to thank the DCAD. The authors are indebted to Josie Harper (director of athletics), Kathy Slattery (director of sports information), and Kathy's staff over the past 27 years. Many of the images used were captured by Kathy's camera.

The special collections library staff was equally helpful. Barbara Krieger, Sarah Hartwell, Eric Esau, Bonnie Wallin, and Joshua Shaw helped identify images that illustrate primarily the first 75 years of football at Dartmouth.

Special thanks also are extended to Edward Connery Lathem, dean of libraries and librarian of the college emeritus, and to Philip Cronenwett, former special collections librarian at Dartmouth. Thanks also go to two invaluable resources and friends: author and editor Tim Cohane and sportswriter Bruce Wood.

About the Authors

David Shribman, Dartmouth class of 1976, became executive editor of the *Pittsburgh Post-Gazette* in 2003 after more than 25 years as a writer and editor for the *Buffalo Evening News*, the *Washington Star*, the *New York Times*, the *Wall Street Journal*, and the *Boston Globe*. He was awarded a Pulitzer Prize in 1995 for his national political coverage. A trustee of Dartmouth College from 1993 to 2003, he is the author of *A Century of Dartmouth Football (1881–1980)* and co-editor, with Edward Connery Lathem, of *Miraculously Builded in Our Hearts: A Dartmouth Reader*.

Jack DeGange, a graduate of Bates College, was sports information director at Dartmouth from 1968 to 1977 and has been a newspaper, corporate, and academic communicator for more than 40 years. He lives in Lebanon, New Hampshire, and continues to write about Dartmouth and Ivy League athletics.

INTRODUCTION

There was a game that did not end until two days after it was over. There was a game played in a ferocious hurricane. There was a jinx that lasted more than a half-century, and there were winning streaks in four decades that reached 15 games. There was a coach known as Fat, another known as Tuss, and a third called the Bullet. There was a player known as Air Mail, another known as Special Delivery, and two (stars, both of them) called Swede. There was a national championship, as well as 2 Lambert Trophies, 9 undefeated seasons, 17 Ivy League championships, and, most important of all, 45 victories against Harvard.

Dartmouth. Football. A place and a game, linked inextricably. Dartmouth College excels in fields beyond the gridiron. Football is played in college towns far beyond Hanover. But there is something about the two of them—maybe the special kind of crispness that comes with an autumn afternoon in New Hampshire, maybe the mix of brain and brawn that the game requires—that has produced a beguiling mix, season after season, era after era, as the backs go tearing by.

Football is America's fall game, and a surprising number of its roots are in the rocky soil of New Hampshire. It was here, at Dartmouth, that a special style of play developed (the flying wedge, pioneered in Hanover), a special tradition grew (Dartmouth men account for more than 60 college coaching stints across the country, including the universities of Illinois, Iowa, Minnesota, Wisconsin, Nebraska, Kansas, Colorado, California, Oregon, Washington, and Massachusetts), a special spirit blossomed, and a special American tradition flourished. For this is a special setting, peculiarly congenial to tailbacks and tailgates, and over the years Dartmouth has had special success on the fields of autumn. More Ivy wins than any other college. More championships than any other. More points. More fun, almost surely. More, more, more, and from the view of the men and women of Dartmouth, better too. You can recognize members of this special species because they are the only adults in their circle who still have their college warm-up jackets.

This is the place where Jay Fiedler passed, where David Shula caught, where Don MacKinnon centered, where Hank Paulson blocked, where Reggie Williams tackled, where Nick Lowery kicked, and where Murry Bowden prowled the defensive backfield (his shoulders held in place with a special harness). This is the place where Earl Blaik coached before he went to Army and where Joe Yukica presided after he coached at Boston College. This is the place where the game's only human-steps play was developed. (The short story is that Sam Hawken, a halfback in running shoes, leaped off the backs of crouching linemen to intimidate Princeton's masterly kicker, Charlie Gogolak.) This is the place where, still, the names Jake and Buddy need no surname and no introduction.

For there is nothing in this world quite like the fellowship of Dartmouth Night, nothing quite like the sight of a chilled crowd huddled against the wind and seen against the tartan blanket draped on Balch Hill after the leaves have fallen, and nothing quite like the stories that these Dartmouth people tell. Dartmouth is, after all, not so much a college as a collection of stories about a college.

The stories: The time, in that first season, when the game against Amherst was cancelled because the snow was too stubborn. The time the coach left Hanover and enlisted in World War I, a man in his fifth decade signing up as a private. ("I've got to go," he told his players, because he could not bear the notion that they might fight overseas without him.) The time Dartmouth, winless in its first 16 games with Harvard (and losing 5 of those games by 48 points or more), traveled down to Cambridge to dedicate the new stadium and emerged with a win so sweet that the taste of it would linger 100 seasons later.

More stories: The time (speaking of Harvard exactly a century later) a spindly end made a thrilling catch that was the centerpiece of one of the most stunning victories ever over the Crimson. The time the boys from New Hampshire (along with 8,000 alumni) traveled all the way to Chicago to defeat Amos Alonzo Stagg's Maroons and to win the national championship. The time (the last time, it turns out) that two undefeated, nationally ranked Ivy League teams clashed before 60,000 people, producing Dartmouth's 10-0 victory over Yale and leading to a championship season that has no equal in the history of this college or any other. (The evidence: These guys sculpted six shutouts and surrendered only 42 points all season. Beat that.) The time Dartmouth defeated Princeton to end Old Nassau's 17-game win streak and claim the Eastern championship. The time Dartmouth ventured south for the last game in Palmer Stadium and put the last sparkling touches on Dartmouth's first 10-0-0 season.

The times, the times. The times of our lives. And as these pages prove, echo swells the sweet refrain.

One

SHAPING THE GAME

THE EARLY YEARS

It was a young game. No one knew its rules, and no one mastered its nuances. No one even knew whether it would survive. Its early days on Hanover Plain were not glorious. The boys from Dartmouth did not know that, a century later, they would be regarded as pioneers. In truth, the boys from Dartmouth did not really know how to play this game. When a ragtag group assembled, way back in 1882, to play Harvard, the results were not pretty. The Dartmouths did not score; the Harvards racked up 53 points. "If there is any game that Dartmouth can play better than foot-ball," the *Dartmouth* editorialized, "it would be well to encourage it."

But there was no substitute for football at Dartmouth, then or now. The game persisted, and Dartmouth prevailed. The first goalposts went up in 1876. The first game was in 1881. The first big moment was in 1884, when someone had the bright idea of bringing the very best team in the land up to Hanover. The thinking was that a visit from Yale would breathe life into football at Dartmouth. The result was a 113-0 loss. Yale did not return to Dartmouth for 87 years.

Yet the story did not end there. There were early successes, particularly a 7-1-0 season in 1889, largely the work of a football genius named Bill Odlin '90. But mostly it was a muddle, and mostly the results were mediocre—until the turn of the century. Then Dartmouth's fortunes turned too. In the college archives rests a book called *Three Years of Football at Dartmouth*, by Louis P. Benezet. It is a chronicle of the seasons of 1901, 1902, and 1903. "It is the simple story," Benezet says in his foreword, "of the events of three seasons upon which Dartmouth men will like to dwell."

There was much to dwell upon in those three seasons (with a combined record of 24-4-1, with Dartmouth scoring 614 points and giving up only 108) and beyond. But perhaps the most enduring impact of football at Dartmouth in those years was not on the field but in the rule book. Edward K. Hall '92 is remembered at Dartmouth for donating Dick's House, the college infirmary, in memory of his son, Richard D. Hall '27, but he is remembered in football circles for his long service on the committee that wrote the new rules of the game, including those governing the forward pass. "There's no one," said T. A. D. Jones, the legendary Yale coach, "who has done so much for the game of football."

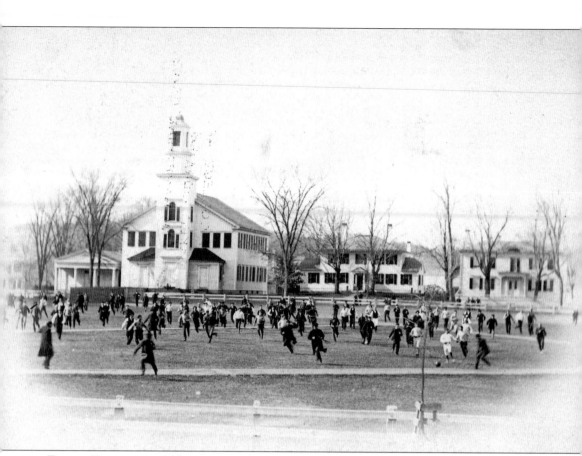

EARLY FOOTBALL. "Old Division," later known as "Whole Division," was Dartmouth's distinctive football game in the mid-19th century. Seniors and sophomores dueled against freshmen and juniors, kicking a leather case inflated by a bladder. The contest included every student not physically incapacitated. The "field," originally the entire campus, was later narrowed to "the college yard," now the Green. Even then it was an autumn ritual; baseball already reigned in the springtime. The buildings in the background of this photograph (including the Church of Christ) that had not already been moved or replaced were relocated from the north end of the Green when Baker Library was built in the 1920s.

JOHN INGHAM '77. In 1876–1877, John Ingham and two friends, Chalmers Stevens and Lewis Parkhurst, erected goalposts on the Green. Whole Division was still in vogue at Dartmouth, and the rugby-style goals did not survive the year. Ingham, from Lebanon, New Hampshire, went on to become a minister in several Midwestern states.

CHALMERS STEVENS '77. Chalmers Stevens, John Ingham's classmate, was part of the early attempt to introduce football at Dartmouth. The sport included rules that stated, "No hacking, throttling or tripping shall be allowed under any circumstances." A promising career as an astronomer took Stevens to Argentina, where he was killed instantly by a stroke of lightning while at the breakfast table in 1884.

11

LEWIS PARKHURST '78. While he was one of Dartmouth's football founders and was captain of his class team in 1877, Lewis Parkhurst is better known as the prominent Boston businessman who was elected in 1915 and served for several decades as a trustee of the college. In 1912, he and his wife gave Parkhurst Hall, Dartmouth's administration building, in memory of their son Wilder '07, who died during his sophomore year.

CLARENCE HOWLAND '84. Clarence Howland started "modern football at Dartmouth." Though efforts to arrange a game in 1880 were unsuccessful, Howland was captain, coach, and "rusher" from 1880 to 1883. He is regarded as the "father of Dartmouth football." As eligibility rules were flexible in those days, he later played at Columbia while attending law school.

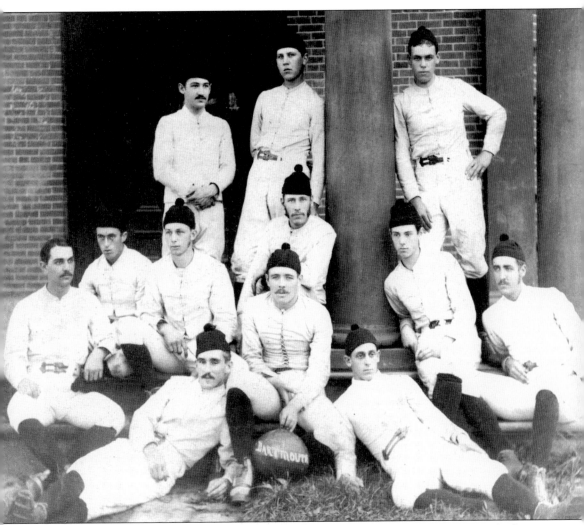

THE 1881 TEAM AND CHARLES OAKES '83. Dartmouth's first football game was against Amherst on November 16, 1881, at Hanover. Dartmouth won 1-0. The only touchdown was scored by Charles Oakes (seen in the left foreground in the photograph), who wrote to his mother, "We played a game of foot-ball Wednesday with Amerst [*sic*]. It was the first game we ever played. I 'spect I was the hero of this occasion. I made the touchdown and several good runs and at the end of the game the boys rode me around the campus on their shoulders. The Proffessors [*sic*] ran around, clapped their hands, shouted, jumped up and down and fairly were mad. One Amerst fellow complimented me and said I could play as well as Camp of Yale. Camp is the best player in the country." A rematch at Springfield on Thanksgiving Day, played in snow, slush, and mud, was declared a draw after 30 minutes. The teams adjourned to a joint dinner.

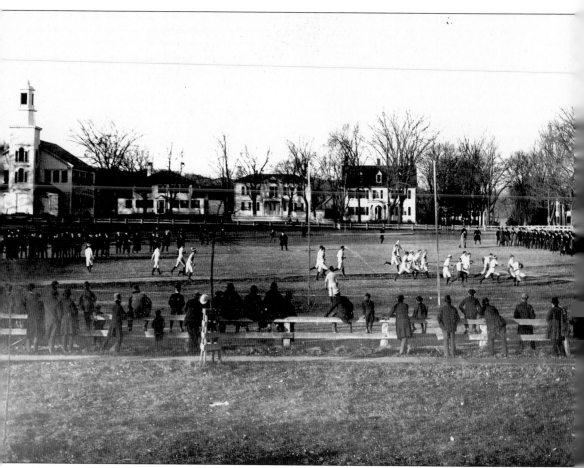

THE GAME TAKES HOLD. During the 1880s, Dartmouth's field for occasional home games was on the Green. After the first game at Harvard, a 53-0 loss, in 1882, a headline in the *Dartmouth* exclaimed, "Rugby is Dead!" The student paper was surprisingly positive in 1884, running the headline "Dartmouth Eleven Acquit Themselves Very Creditably" after powerful Yale was invited to Hanover and "educated" Dartmouth 113-0. Dartmouth fielded no team in 1885, but the next four seasons saw the game take root under Bill Odlin. His leadership ensured the future of football at Dartmouth. In 1889, Dartmouth built a 7-1-0 record, losing only to Harvard and outscoring its opponents 239-72.

BILL ODLIN '90. As captain and coach from 1886 to 1889, Bill Odlin brought innovations to Dartmouth football that included the calling of signals by numbers. A fullback and outstanding kicker, Odlin developed the wedge (later perfected as the flying wedge by Loren Deland at Harvard) that bowled over the opposing team as it marched down the field.

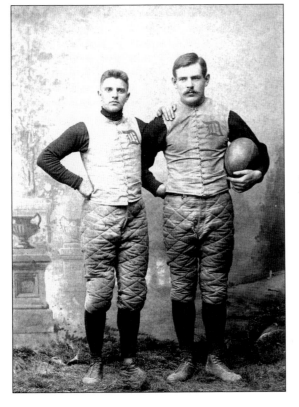

EDWARD K. HALL '92 AND FRED FOLSOM '95. E. K. Hall (left) was captain and played end on the 1891 team. His contributions to college football are described on page 24. Fred Folsom was an end and a rusher in 1893. From 1903 to 1906, Folsom coached Dartmouth to a 29-5-4 record. He then coached the University of Colorado to a 41-16 record from 1907 to 1915 before becoming a prominent member of the law school faculty. In 1965, 20 years after Folsom's death, Colorado named its football stadium Folsom Field.

WALTER MCCORNACK '97. In 1896, Walter McCornack became Dartmouth's first All-American. Selected to Walter Camp's third team, McCornack was a quarterback and two-time captain who returned to coach the Dartmouth teams in 1901 and 1902. The 1901 team finished 9-1-0. McCornack's coaching methods set the stage for the subsequent success of Fred Folsom's teams.

JOHN O'CONNOR '02. John O'Connor, captain and end on the 1901 team, coached at Bowdoin while earning his medical degree. Before becoming a physician in Manchester, he succeeded Fred Folsom as Dartmouth's coach, compiling a 14-1-2 record in 1907 and 1908 with players that included future coach Jess Hawley.

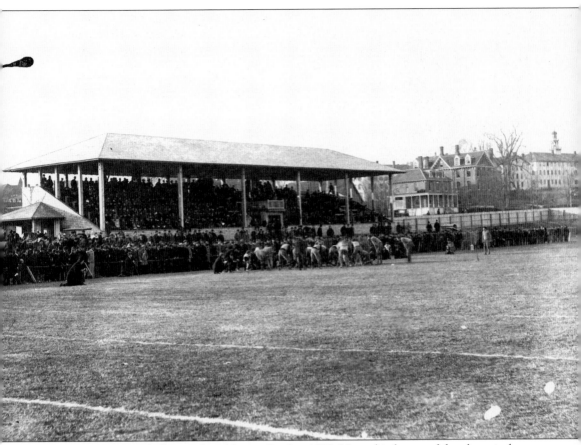

ALUMNI OVAL. Football moved to Alumni Oval in 1893. Named in honor of the alumni whose generosity made it possible, the facility included the football field, a baseball diamond, and a quarter-mile cinder track that was banked to accommodate cycling races, which were a feature in that era. Alumni Oval was dedicated during commencement exercises in June 1893, and the first football game, not recorded in official records, was played against Harvard's second eleven in October 1893. The covered grandstand, which included dressing rooms beneath, burned in 1901, but the field continued in service until Memorial Field was built in 1923.

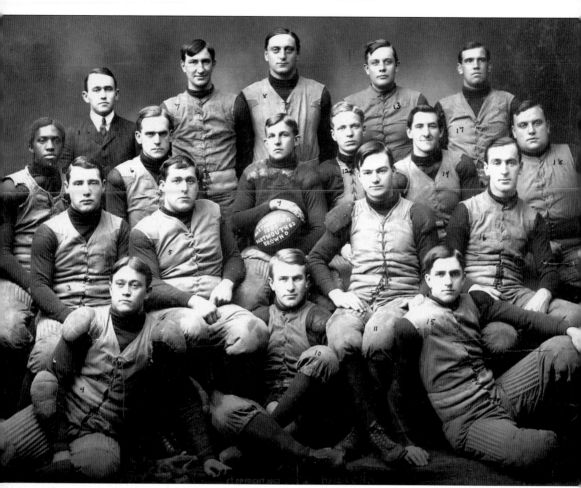

THE 1903 TEAM. Dartmouth's 1903 team is regarded as one of the best in Green annals for many reasons, not the least of which being that it recorded the first-ever win over Harvard in the dedication game of Harvard Stadium. This team posted a 9-1-0 record, shut out 8 of 10 opponents, and scored 242 points while yielding only 23, most of them in the lone loss at Princeton 17-0. Four players earned All-America recognition from Walter Camp, the leading selector in that era. Henry Hooper, a freshman giant (seen at the far right in the photograph), was Camp's first-team center. Tragically, in February 1904 he died of pneumonia at Mary Hitchcock Hospital in Hanover. Captain Myron Witham, the quarterback, and guard Joe Gilman were second-team All-Americans, while tackle Leigh Turner made Camp's third team. Gilman, Ralph Glaze, and James Vaughn were also honored in 1904 and 1905.

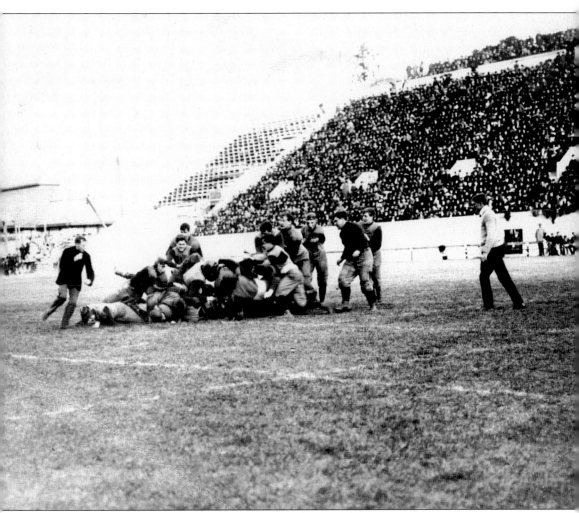

THE DEDICATION OF HARVARD STADIUM. Dartmouth was Harvard's opponent on November 14, 1903, for the dedication of the world's first massive reinforced-concrete structure and the first large, permanent arena for college athletics in America. It was a historic day for Harvard—and for Dartmouth, an 11-0 winner. After 18 meetings that included 17 shutouts, it was the first time that Dartmouth defeated the Crimson. Myron Witham's fumble recovery led to the stadium's first touchdown, scored by Leigh Turner. Construction remained to be completed on the stadium, whose dimensions shaped the rules of college football in years to come. In the centennial game in 2003, another underdog Dartmouth team defeated Harvard 30-16.

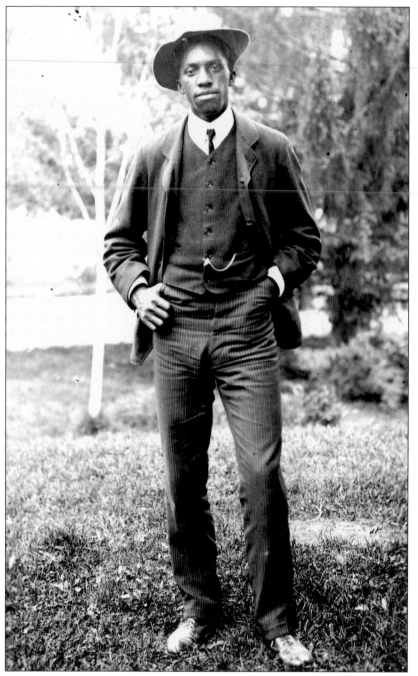

MATTHEW BULLOCK '04. The son of illiterate parents who were both born as slaves, Matt Bullock was the first black football player at Dartmouth and the first black to be named head football coach at a predominantly white college. An end, Bullock played from 1901 to 1903 and was an honorable mention All-American in 1902. Fresh from Dartmouth in 1904, he became the coach at Massachusetts Agricultural College, now the University of Massachusetts. Bullock later graduated from Harvard Law School, practiced in Boston for many years, and served nine different governors as a member of the Massachusetts Parole Board.

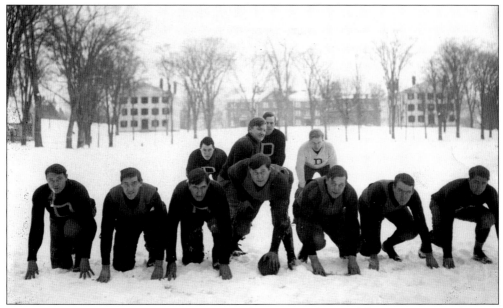

THE 1904 TEAM AND DARTMOUTH HALL. The starting eleven of the 1904 team, with many players returning from 1903, strike a late-season pose on Dartmouth's snow-covered green, likely before a scoreless tie at Harvard, the only blemish on a 7-0-1 season. In the hazy background is Dartmouth Row without Dartmouth Hall (Fayerweather Hall is in the middle). The winter of 1903–1904 was memorable. In February 1904, between two notable football seasons, Dartmouth Hall was destroyed by fire. Dating from 1784, it was the last building that linked the modern college to its founding years.

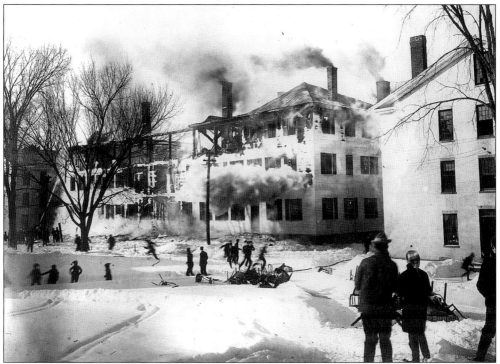

RALPH GLAZE '06. A Walter Camp All-America end in 1904 and 1905 (when he was a first-team selection), Ralph Glaze also pitched two no-hitters for Dartmouth's baseball team and then won 15 games as a pitcher for the Boston Red Sox from 1906 to 1908. Glaze came to Dartmouth from Denver; he returned west to coach Baylor's fledgling football team to a 6-1-1 record in 1910. Baylor's only loss was a forfeit to Texas. The teams were tied 6-6 when Glaze, charging biased officiating, pulled his team from the field in the third period.

JOHN GLAZE '08. Ralph Glaze's brother, known to his teammates as "Muldoon," was his brother's athletic equal. John Glaze was quarterback and two-year captain in 1906–1907. He played on coach John O'Connor's 1907 team, which was 8-0-1 (the tie was a scoreless duel with Vermont). Eight of nine opponents were shut out. Like Ralph Glaze, John Glaze was also a baseball pitcher, and he was said to be the first college pitcher to throw a spitball.

MOOSE ENGLEHORN '14. Wesley "Moose" Englehorn came from Spokane, Washington, and arrived at Dartmouth after playing one year at Washington State. An All-America tackle in 1912, he was elected captain of the 1913 team but was declared ineligible because of his year at WSU. He became an assistant coach and was also class president. Shortly before he died in 1993 at age 103, he said, "It's the football I remember best . . . the teammates . . . the teamwork."

E. K. HALL '92. After playing at Dartmouth, Edward K. Hall organized football and track at the University of Illinois. His impact on Illini athletics was such that Illinois adopted Dartmouth green as the university color. (It has since been changed.) His subsequent impact on college football was far greater and earned him a place in the College Football Hall of Fame. As injuries became rampant in the early 1900s, dramatic changes were demanded. Hall, a prominent businessman, was invited to serve on the NCAA's Football Rules Committee in 1905. He chaired the committee from 1911 until his death in 1932. Under Hall, rules featuring speed and the forward pass replaced mass play and brute strength. Yale's Walter Camp is regarded as the father of American football, but E. K. Hall's leadership ensured its future. To this day, there is no feature of college football, large or small, that does not reflect the genius of E. K. Hall.

Two

MORE THAN AN EASTERN COLLEGE

One player, Edward Healey '18, might have been the boxer to dethrone Jack Dempsey, but he turned instead to the gridiron. He became the first man whose contract was sold in the young National Football League and the only Dartmouth player enshrined in both the college and pro football halls of fame. Another, Bill Cunningham '19, turned down 25,000 pesos a year to be a major general in the Mexican army to become instead a reporter for the *Boston Post* and one of the most famous sportswriters of his day. A third, Nate Parker '26, was captain of the 1925 national championship team and a Rhodes scholar. A fourth, Andrew "Swede" Oberlander '26, was one of the finest backs in the history of Dartmouth, prompting Grantland Rice to say that under Oberlander, Dartmouth had "the finest forward passing attack that any team ever used before."

Healey, Cunningham, Parker, and Oberlander—along with multisport athletes Myles Lane '28, who sits in the hall of fame in football and hockey, and Bill Morton '32, an All-American in hockey and football—took Dartmouth from a regional power to a national power. These years represent the coming of age of both Dartmouth as a sporting power and football as a game of lore and luster.

Between 1911 and 1930, Dartmouth won 128 games—more than six a year, on average. In a 30-game period from 1922 to 1926, the Green lost but once, and that was a 32-7 defeat to Cornell in a clash of undefeated titans on the day Memorial Field was dedicated. Two years later, Dartmouth defeated another talented Cornell eleven 62-13 en route to the national championship.

While Cornell was Dartmouth's biggest rival in those years, its most enduring accomplishment came against Yale, which had outscored Dartmouth 308-0 in the first eight games they played and 389-33 in 14 games between 1884 and 1930. Then, in 1931, Dartmouth scored as many points in one contest as it had in the entire series, producing a 33-33 deadlock—by far the sweetest tie in Dartmouth sporting history. It was a coming of age in its own right.

FRANK CAVANAUGH '99. A hall of fame coach, Cavanaugh left Dartmouth after his junior year to become the football coach at Cincinnati. He returned to Dartmouth in 1911 with a law degree and a no-nonsense style, telling his team, "If I were teaching Greek or Latin, I should not be satisfied with a half-way translation." In five seasons he guided Dartmouth to a 42-9-3 record. At age 40, the father of six (eventually nine) followed "his boys" into World War I, enlisting as a private but earning a battlefield commission. His heroism became the subject of a World War II movie, *The Iron Major*.

CLARENCE SPEARS '17. Twice an All-America guard in 1914–1915, Spears had a cherubic face and girth (he was 5 feet 10 inches tall and weighed 240 pounds) that prompted the nicknames "Cupid" and "Fat." He is in the hall of fame as a player but is equally memorable as a coach. He succeeded Frank Cavanaugh at Dartmouth from 1917 to 1920 (with a record of 21-9-1) and then combined a medical practice with 24 more years of coaching at Wisconsin, West Virginia, Minnesota, and Oregon.

EDWARD HEALEY '18. Healey might have been a great heavyweight boxer, but his mother said no. A tackle for Frank Cavanaugh and Fat Spears, he was playing for Rock Island in the fledgling NFL when George Halas bought his contract for $100 to settle a debt. It was twice what Halas paid to buy the franchise that became the Chicago Bears, Healey's team from 1922 to 1927. He is the only Dartmouth player in both the college and pro football halls of fame.

ADOLPH YOUNGSTROM '18. Adolph "Swede" Youngstrom returned from World War I service to become an All-America guard in 1919. He became a legend for his play in a 7-7 tie with Colgate in 1919 that was billed as the Eastern championship game. Youngstrom blocked four punts. The last one hit him in the chest. He picked up the loose ball and ran five yards to score. He then kicked the extra point (it bounced off the upright) to create the standoff.

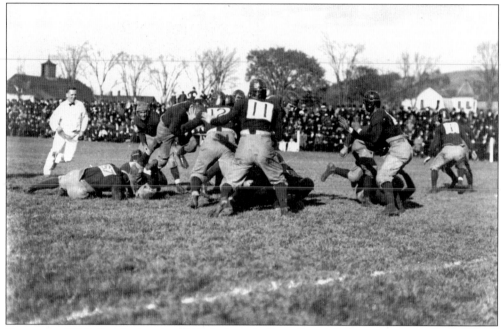

CLASSICS, 1919. Bracketing the 1919 duels with Cornell and Colgate, Dartmouth played two notable games. As a feature of the college's sesquicentennial celebration (1769–1919), Penn State came to Hanover (above). Dartmouth won the hard-fought game 19-13. A week after Penn State handed Penn its first loss of the season and Dartmouth tied Colgate, Dartmouth and Penn met at the Polo Grounds in New York (below). Dartmouth built a lead and held on to win 20-19. A week later, unbeaten Dartmouth (6-0-1) lost to Brown 7-6. In a return engagement that was part of Penn State's centennial celebration in 1920, Dartmouth lost 14-7.

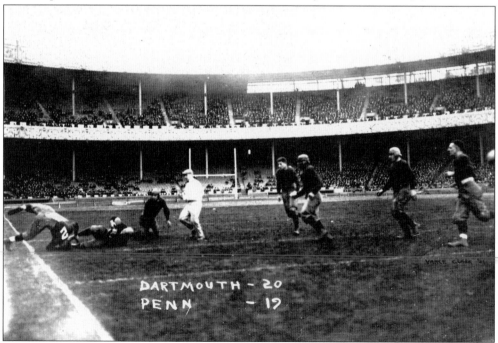

BILL CUNNINGHAM '19. Elijah W. "Bill" Cunningham came to Dartmouth from Blossom Prairie, Texas, via Dallas. He became an All-America center in 1920. He then returned to Dallas to coach Southern Methodist, to launch his newspaper career, and to match those salaries with side money earned by playing piano in a leading Dallas movie house. In short order, he was in Boston, where over four decades, he became a renowned columnist and radio commentator. Cunningham traveled near and far, interviewing everyone from Al Capone and the Prince of Wales to Ted Williams—and many others in between. On frequent visits to Hanover, he held court from the piano in the Hanover Inn bar. He was one of the "larger than life" personalities of his day.

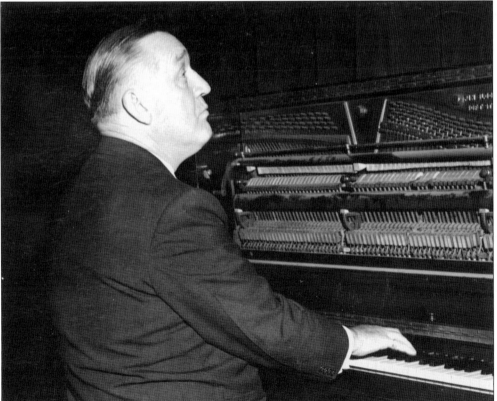

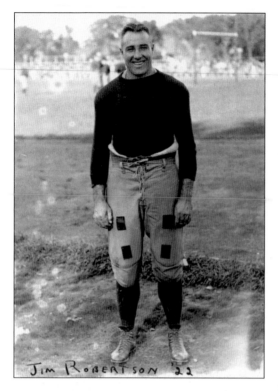

Jim Robertson '22

JIM ROBERTSON '20. As so many did, Jim Robertson returned from World War I service to become a star on Dartmouth's postwar team. A halfback who kicked a 50-yard field goal to help beat Cornell 9-0 at the Polo Grounds in 1919, Robertson was the captain of teams in 1920 and 1921 that had a combined record of 13-4-1 and were among the East's best teams.

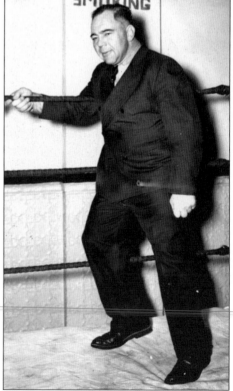

GUSTAVE SONNENBERG '20. Gustave "Gus" Sonnenberg, a tackle, was Bill Cunningham's roommate and teammate at Dartmouth. When Cunningham graduated, Sonnenberg left too, without a degree (he missed his friend). Sonnenberg played pro football and then became one of the great heavyweight wrestlers of the 1920s. The "Flying Dutchman" introduced the flying tackle to pro wrestling and was world champion from 1929 to 1931. Sports historian Frank Menke called Sonnenberg the "revolutionizer" of modern wrestling.

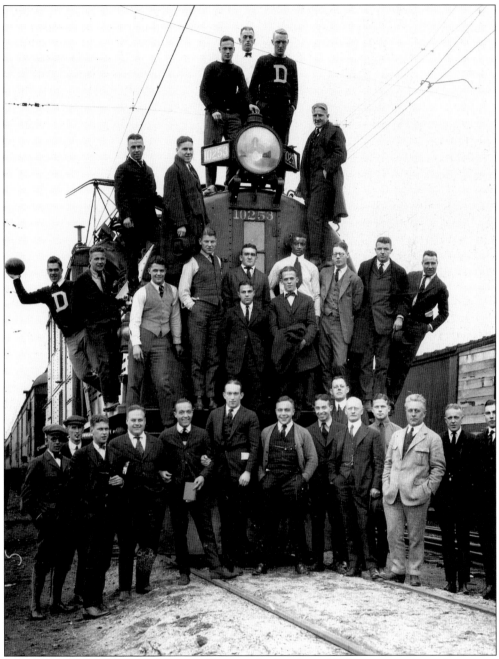

ON TO SEATTLE. East met West as Dartmouth closed its 1920 season with its first intersectional game in history—a cross-country excursion to dedicate the University of Washington's new stadium in Seattle. After beating Brown at old Braves Field, Dartmouth left Boston, making stops in Cleveland, Chicago, and Minneapolis for alumni gatherings. On arrival in Seattle, a sign on a building decreed, "3,000 Miles to Play Washington! Dartmouth, the Town is Yours!" And it was. The Green dispelled West Coast bias that eastern football was not up to western standards. Dartmouth won 27-7. Over the years, Dartmouth football teams played six stadium dedication games—and won all but their own.

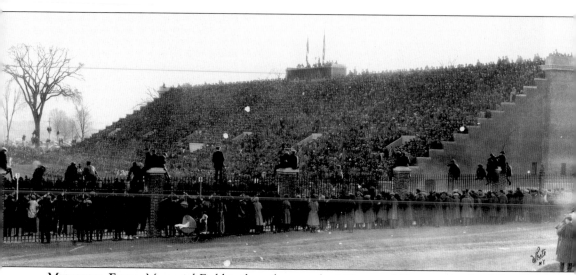

MEMORIAL FIELD. Memorial Field is the tribute to the 112 men of Dartmouth who fell in the Great War. When it was built at a cost of $270,000 in 1922–1923, it also honored surviving Dartmouth veterans from the Civil War. Dartmouth history professor Charles Wood wrote, "A football stadium may seem a curious kind of war memorial . . . but in the 1920s it was a choice that made sense . . . a stadium looking proudly but sadly to the past even as the nature of its athletic function allowed the College to look expectantly forward." Memorial Field, replacing Alumni Oval as Dartmouth's home field, included five miles of underground drainage pipe. The brick-and-concrete West Stands seat 7,100 spectators. On November 3, 1923, after pomp and dedication speeches, Cornell and Dartmouth played football. Led by George Pfann, Cornell departed with a 32-7 win en route to an undefeated season. Dartmouth, which finished 8-1 in 1923, would not lose again until the 1926 season.

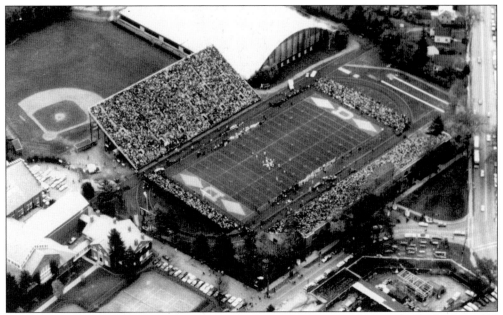

CAPACITY CROWDS. Beginning with the Princeton game in 1968, which drew 19,635 spectators, the next decade of Dartmouth football saw a parade of games that drew crowds of 20,000 or more. This aerial view shows the crowd of 30,336 for the Harvard game in 1976. The Memorial Field attendance record of 21,530 was set at the Harvard game in 1974.

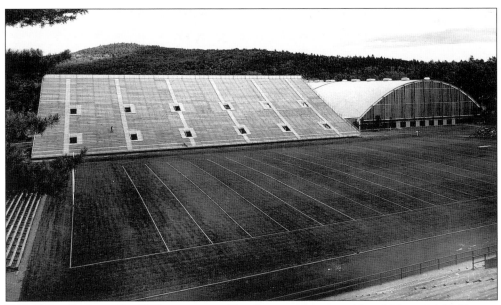

THE EAST STANDS. In 1968, temporary bleachers on the east side of Memorial Field were replaced with 9,500 permanent seats, and a new irrigation and drainage system was embedded in the field. The expanded seating increased the stadium's seating capacity to 20,816, including end-zone seating, to accommodate crowds for regularly scheduled home games with the Big Three (Harvard, Yale, and Princeton) that actually began in 1964, when Princeton visited Hanover.

JACKSON CANNELL '19. Jackson "Jack" Cannell quarterbacked Everett High School (in Everett, Massachusetts) to an undefeated season and a mythical national schoolboy title in 1914. He was captain of Dartmouth's 1919 team and succeeded Clarence Spears as coach in 1921–1922. Cannell returned to coach Dartmouth from 1929 to 1933. His overall coaching record was 39-19-4, but his teams were 8-8-1 in 1932 and 1933, signaling it was time to change.

JESS HAWLEY '09. A halfback and New England track champion in three events at Dartmouth, Jess Hawley became known as a master of football trickery as coach at Iowa from 1911 to 1915. He also grasped the possibilities of the forward pass, and when he left business to coach Dartmouth from 1923 to 1928, the Green proved perfect instruments for his gridiron guile. "Rhythm and timed unison in thinking and acting give eleven eager men an irresistible advantage over another eleven," he wrote after the historic 1925 season.

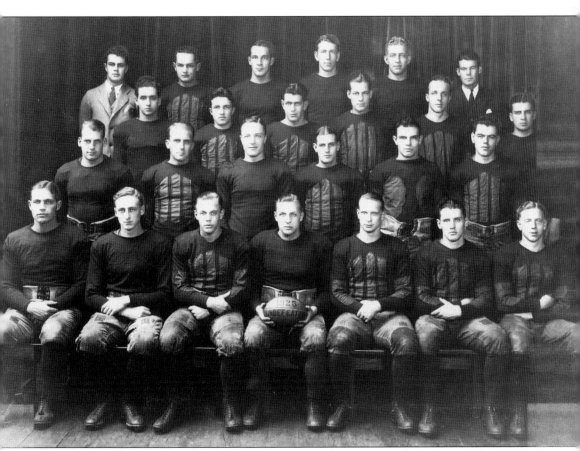

THE 1925 NATIONAL CHAMPIONS. The 1925 season is the centerpiece of an extraordinary era in Dartmouth football history. In a span of 30 games over four seasons, the Green lost once. The 1925 team produced Dartmouth's first undefeated and untied season and the national championship. Dartmouth finished 8-0-0 with five shutouts. The offense, devised by coach Jess Hawley and executed to perfection by Swede Oberlander and his teammates, scored 340 points. The last two games were most memorable. Cornell returned to Hanover for the first time since the 1923 dedication game and was obliterated 62-13. A week later, Dartmouth traveled west to dominate Amos Alonzo Stagg's University of Chicago team 33-7 and claim its crown. Grantland Rice wrote, "In the midst of all the noise and excitement, football's main banner for the waning year goes to the peace and far-away restfulness of Dartmouth, the college on the hill."

SWEDE OBERLANDER '26.
Andrew James "Swede" Oberlander was a tackle when he arrived at Dartmouth from Everett, Massachusetts, and was an All-America halfback-quarterback when he graduated, declining on departure an offer of $25,000 to play pro football and adhering to his plans for a career in medicine. His conversion to the backfield was one of Jess Hawley's best moves. Oberlander had a direct hand in 48 of 62 points against Cornell in 1925, including six touchdown passes that remain a Dartmouth record. He had four more scoring passes in the finale at Chicago. In that storied 1925 season, he ran for 12 touchdowns and passed for 14 more. Oberlander's leading role in a 16-0-1 record in 1924 and 1925 secured his election to the Football Hall of Fame.

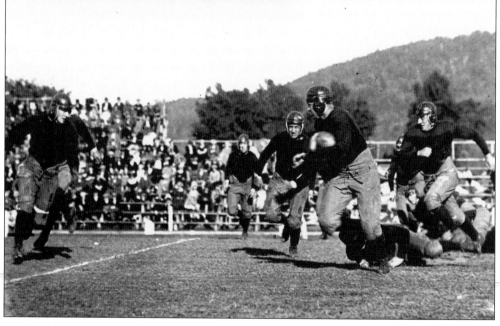

NATHAN PARKER '26. Nate Parker, captain of the 1925 championship team, was also class president, Phi Beta Kappa, and a Rhodes scholar. He joined Oberlander, guard Dutch Diehl, and end George Tully as a first-team All-American in 1925. But for all his success on the gridiron, the game that Parker remembered most was in 1924, when Dartmouth failed on four rushes at the Yale goal and settled for a 14-14 tie, the lone blemish in two great seasons. Years later, the Pittsburgh business leader said, "That was the most disappointing day of my life."

EDDIE "DEATH" DOOLEY '27. Eddie Dooley, a fixture at quarterback and defensive back on the 1923 and 1924 teams, suffered a back injury late in the 1924 season and left college to recuperate. He missed the 1925 season but returned in 1926— with a bride, making him the first married man to be allowed to play football at Dartmouth. He became a sportswriter, a congressman, and the chairman of the New York State Athletic Commission. In 1934, he helped coax Earl Blaik to Hanover.

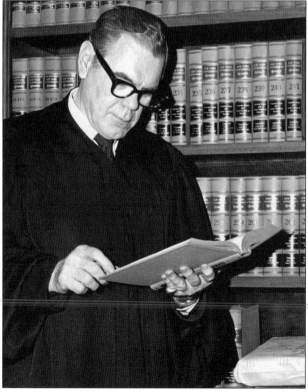

MYLES LANE '28. Myles Lane was a three-sport star who is Dartmouth's only inductee in both the football and hockey halls of fame. (Baseball was his third sport.) From 1925 to 1927, he was Dartmouth football's scoring leader, amassing a record 307 points (48 touchdowns and 19 extra points). He played for the Boston Bruins in their 1929 Stanley Cup season, and he was the football coach at Boston University while earning his law degree at Boston College. As a U.S. attorney in New York, he prosecuted gangster Frank Costello and espionage conspirators Julius and Ethel Rosenberg. He was later a justice of the New York State Supreme Court.

ALTON MARSTERS '30. Known as "Special Delivery," halfback Alton Marsters scored six touchdowns against Hobart and had 109 points by Dartmouth's sixth game at Yale in 1929. A superstitious man, Marsters wore the same set of shoulder pads at Arlington High School (in Arlington, Massachusetts) and at Dartmouth. At Yale, the pads were misplaced, and Marsters accepted borrowed pads. He was leading interference when a Yale defender kicked him, fracturing his spine. Marsters, who felt he could not be hurt on the football field, never played another game.

HAROLD HAMM '30. Harold Hamm was Alton Marsters's classmate and teammate at Arlington High School and Dartmouth. He was a promising fullback, but in the summer of 1928, as a camp counselor on New Hampshire's Lake Winnipesaukee, he was struck by lightning and was killed instantly. In his memory, his jersey number (22) was "retired" by his teammates. Historic memory in the equipment room kept the number retired for nearly 60 years. It was reactivated in 1985.

BILL MORTON '32. In 1931, Bill "Air Mail" Morton teamed with halfback Bill McCall to unleash lightning against Yale, which had never lost to Dartmouth. Yale, led by the legendary Albie Booth, built a 33-10 lead, but Dartmouth battled back behind Morton and McCall to trail 33-30. In the waning minutes, McCall held the ball and Morton kicked a 34-yard field goal. Dartmouth "beat" Yale 33-33. The game helped to propel Morton, an All-America in football and hockey and later president of American Express, into the Football Hall of Fame.

ROBERT MICHELET '34. President Ernest M. Hopkins, watching Bob Michelet at football practice in 1933, said, "There is a boy who understands the value and opportunity [an] educational program offers. Michelet enjoys athletics. He plays the game for all it's worth." From Washington, D.C., Michelet was a lineman from 1931 to 1933, captain of the track team, Phi Beta Kappa, and selected as a Rhodes scholar. Shortly before graduation, he died from influenza. His body lay in state in Rollins Chapel.

Three
PRE-IVY LEAGUE
1934–1954

Now began two decades destined to be dominated by two men, one an architect of the modern game and one of football's greatest coaches ever, the other a legend at Brown and Amherst and the commander of the Dartmouth teams that were the first to win six major games.

Earl "Red" Blaik and DeOrmond "Tuss" McLaughry were uniquely men of their times. Blaik was a martinet who preached the gridiron gospel of discipline and sacrifice. McLaughry was a gentle man always described as a gentleman who, lacking the talent possessed by his predecessor and by his successor, Bob Blackman, nonetheless managed to preside over victories against Miami (Ohio), Syracuse, and one of Blaik's Army teams.

The Blaik years were a great spectacle. In the three seasons from 1936 to 1938, Dartmouth racked up a 21-3-3 record and a remarkable 22-game stretch in which the Green was never defeated. At the center of that success was Bob MacLeod, named to 14 All-America teams and described by Grantland Rice in 1938 as the best *defensive* back of the year. The 1937 team, with a record blemished only by ties with Yale and Cornell, fashioned four shutouts and outscored its rivals 173-9 in its first five games. The next year's team won its first seven games and then dropped contests at Cornell and Stanford.

But for all that Dartmouth did in this era, the period was marked by what it did not do. It did not accept an invitation to play in the 1938 Rose Bowl game. "I think that I should feel that we were receiving the money paid for tuition at Dartmouth . . . under some large measure of false pretenses," said president Ernest Martin Hopkins, "if we were to monopolize the attention of the college upon a Rose Bowl game up to the first week of January." Football success was to be celebrated at Hanover, but it was to be kept in perspective.

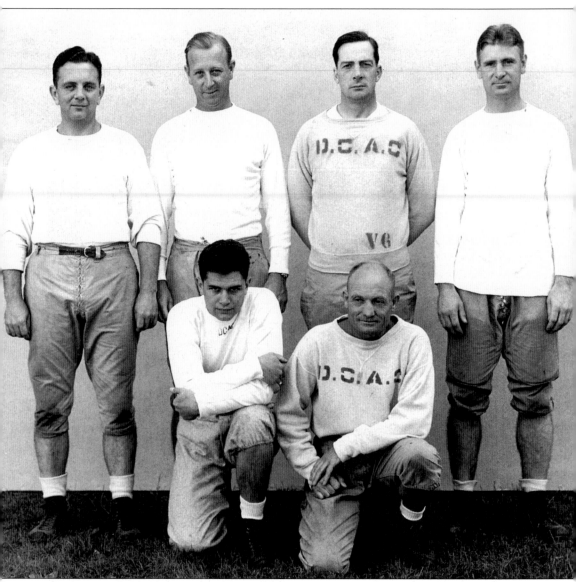

EARL BLAIK. In 1932 and 1933, Dartmouth had football records of 4-4 and 4-4-1. The Green did not score a point in the last three games of the 1933 season. It had been only eight years earlier that Dartmouth was the national champion. When president Ernest M. Hopkins brought Earl Blaik, a former cavalry officer, from West Point to Hanover in 1934, he said, "Earl, always remember that football is incidental to the purpose for which the player is in college." He then added, "But let's have a winner." The coaches who executed with purpose are shown in 1936. They are, from left to right, as follows: (front row) Eddie Chamberlain '36, backs, and trainer Roland Bevan; (back row) Harry Ellinger, line; Andy Gustafson, backs; Earl Blaik; and Joe Donchess, ends. Chamberlain, a back on the 1934 and 1935 teams, went on to become director of admissions at Dartmouth from 1954 to 1979. During Blaik's seven seasons in Hanover, Dartmouth returned to the heights of Eastern college football, building a record of 45-14-4.

CARL "MUTT" RAY '37. When Carl Ray was born, his father said, "He's a funny looking little mutt but I guess we may as well keep him." He remained "Mutt" for the rest of his life. At Dartmouth from 1934 to 1936, he was an indestructible cog in the center of the Green line. When Ray died in 1986, his classmate, Dave Camerer, reminisced with his old coach. Earl Blaik said, "Mutt Ray was a fine center. More important, he was a leader."

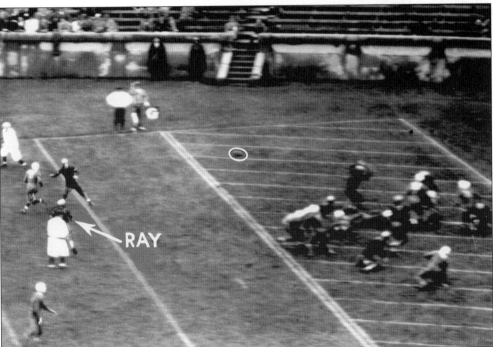

BREAKING THE JINX. Earl Blaik's 1935 team arrived at Yale Bowl with a 5-0 record. Yale had lost once, to Army, but never to Dartmouth. Seven times, Dartmouth drove inside Yale's 10-yard line, but the team scored only once, on Pop Nairne's run. John Handrahan's kick gave Dartmouth a tenuous 7-6 lead into the waning minutes. Then Mutt Ray, at linebacker, intercepted a pass at Yale's 12-yard line and scrambled to the end zone to make the score Dartmouth 14, Yale 6. With two minutes to play, Dartmouth fans tore down the goalposts. After 51 years, Dartmouth finally beat Yale.

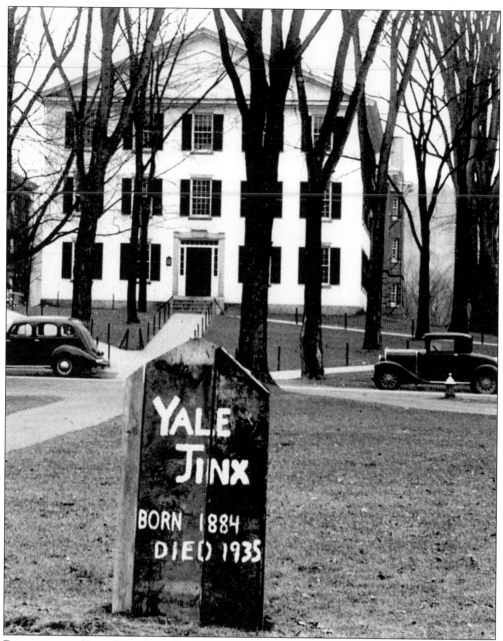

BURYING THE YALE JINX. In eight games with Yale prior to 1900, Dartmouth never scored a point against the Elis, starting with the 113-0 debacle in 1884. The rivalry resumed in 1924, and the 14-14 tie gnawed at Nate Parker '26 for the rest of his life. The teams played a scoreless tie in 1930 and the fabled 33-33 tie in 1931. In 1932, 1933, and 1934, Yale won 6-0, 14-13, and 7-2. Dartmouth's faithful could only wonder what magic was needed to beat Yale. President Hopkins told Earl Blaik, "We're not so much concerned with the other games. Just beat Yale and we'll all be happy." On November 2, 1935, Dartmouth found ecstasy in Yale Bowl. The next day, on the Green in Hanover, the jinx was given a fitting burial.

GORDON BENNETT '37. Gordon Bennett, shown with coach Earl Blaik, was captain of Dartmouth's 1936 team, which beat Yale (again) 11-7. On November 30, 1942, having graduated from Harvard Medical School and just completed his internship at Boston City Hospital, Bennett died from burns suffered while assisting people trapped in the fire that consumed the Cocoanut Grove night club in Boston.

THE 1936 TEAM. The 1936 starters—with Gordon Bennett at right tackle, Mutt Ray at center, and Dave Camerer at left tackle—launched a three-year period of success that reached 22 games without a loss. It began after Bill Osmanski's interception return gave Holy Cross a 7-0 win in game three of the 1936 season. From 1936 to 1938, Dartmouth built a 21-3-3 record and outscored its opponents 740-155.

BOB MACLEOD '39. While Bob MacLeod, the "Wildfire Scot" from Glen Ellyn, Illinois, was a consensus All-American in 1938 for his offensive prowess (he was named to 14 different All-America teams), Grantland Rice called him "the best defensive back of the year." Shown with Earl Blaik and Andy Gustafson, MacLeod was 6-foot-tall, 190-pound wingback Blaik called "the greatest competitive athlete I've ever coached." During three seasons, he did not miss a single play due to injury.

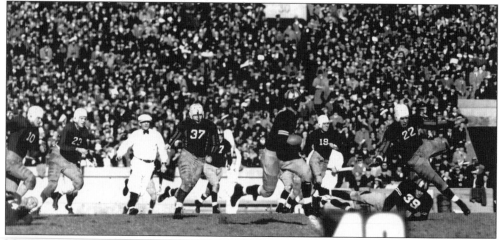

MACLEOD ON THE MOVE. Shown in action during a 24-6 win at Yale in 1938, Bob MacLeod averaged nearly six yards per carry over three seasons. In addition to playing football, MacLeod was an all-league guard on Dartmouth's basketball team. He went on to play two seasons with the Chicago Bears and was then a Marine Corps pilot in the Pacific during World War II. He went on to a long career in magazine publishing. One of Dartmouth's finest athletes of all time, MacLeod was enshrined in the Football Hall of Fame in 1977.

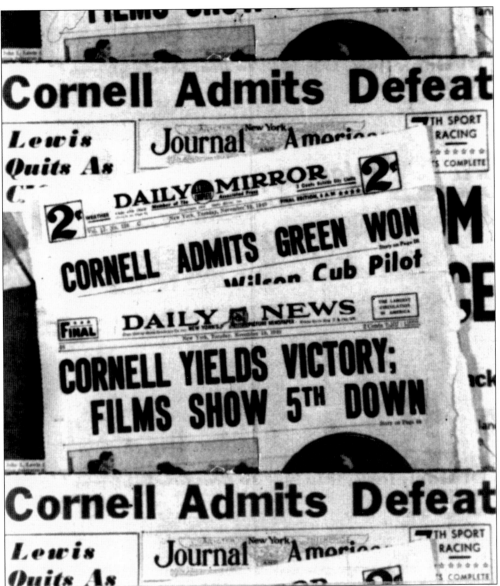

THE FIFTH-DOWN GAME. Cornell was atop the national rankings, riding an 18-game win streak, and an overwhelming favorite at Memorial Field on a gray November 16, 1940. But Earl Blaik's last Dartmouth team held Cornell scoreless and had a 3-0 lead on Bob Krieger's field goal in the fourth period. Then referee William "Red" Friesell lost track of downs as Cornell drove toward Dartmouth's goal. Dartmouth held on fourth down. Despite the protest of his head linesman, Friesell gave Cornell an extra play, and the Big Red scored with two seconds remaining in the game for an apparent 7-3 win. Game films revealed the truth, Friesell admitted his error, and Cornell officials agreed, conceding the game. It remains the only game in Dartmouth history not decided on the field.

LOU YOUNG '41. The captain of the 1940 team, guard Lou Young had a fine football pedigree. His father, Louis Young, had been Penn's football coach from 1923 to 1929, including a national championship eleven in 1924, a year before Dartmouth was the champion. As the fifth-down scenario unfolded, he argued vehemently, but to no avail, with referee Red Friesell. Victory would come later.

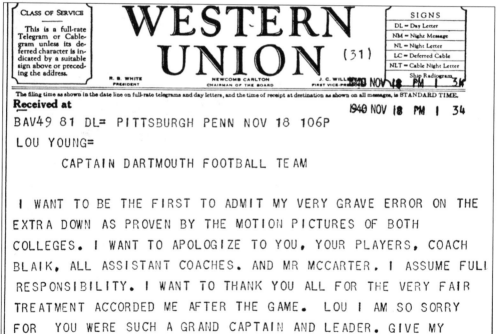

ADMITTING THE ERROR. As he walked off Memorial Field with head linesman Joe McKenney, referee Red Friesell confided, "If I've given them a fifth down, we'll be in an awful pickle." As president Ernest Hopkins and coach Earl Blaik drove Friesell to the train in White River Junction, Vermont, he admitted he had probably made a mistake. In his telegram to Dartmouth captain Lou Young two days later, Friesell apologizes for his grave error.

TUSS MCLAUGHRY. Leaving Hanover to return to West Point was a wrenching decision for Earl Blaik after the 1940 season, but his successor, DeOrmond "Tuss" McLaughry, joined him years later in the College Football Hall of Fame. Except for the time he spent in World War II service from 1943 to 1944, McLaughry coached the Green from 1941 to 1954. McLaughry's coaching credentials were established during 15 years at Brown, starting with the 1926 "Iron Men," who were 9-0-1. (It was Brown's only unbeaten season.) As he demonstrated with his fine teams in 1948 and 1949, when Tuss had talent to work with, he produced winners. More important, as one sportswriter observed, "If my son were to play for any coach, that coach would be Tuss McLaughry."

CHARLES "STUBBY" PEARSON '42. Stubby Pearson broke many hearts in Minnesota when he came east to play basketball for Dartmouth coach Ozzie Cowles. He became captain of the 1941–1942 team, which had a 22-4 record and lost to Stanford in the NCAA championship game. That was after he was center and captain of the 1941 football team. Pearson graduated Phi Beta Kappa and valedictorian of his class. He immediately went to war, becoming a U.S. Navy pilot. In March 1944, he was killed while dive-bombing a Japanese ship during the battle of the Palau Islands.

DALE ARMSTRONG '46. Dale Armstrong returned to Dartmouth in 1946 after winning the Bronze Star with the U.S. Army in Europe. He was captain of the 1948 team, was an All-America end, and also played basketball and baseball. A solid receiver, he made his mark on defense against Harvard in 1948. On successive plays in the third period, Armstrong made tackles for losses of eight and six yards. In the fourth period, with the score 7-7, he hit the quarterback, forcing a fumble. Dartmouth recovered and scored in four plays to win 14-7.

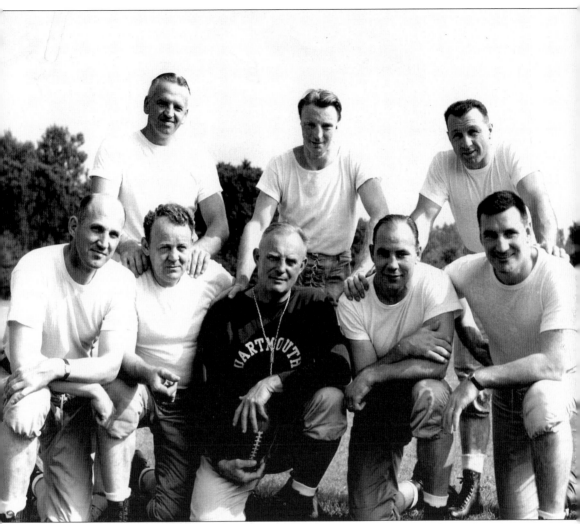

McLaughry's Postwar Staff. In 1948 and 1949, Tuss McLaughry's teams posted successive 6-2 records. Prior to McLaughry's tenure at Dartmouth, the Green's schedule always included early games against small colleges like Bates, Norwich, and Hobart. The 1940s saw Dartmouth play a full major college schedule for the first time. The only 1948–1949 opponent to beat Dartmouth twice was Penn. McLaughry's staff in those notable seasons included the men shown here. From left to right are the following: (front row) Elmer Lampe, John Dell Isola, Tuss McLaughry, Milt Piepul, and Bill Battles; (back row) Tony Dougal (trainer), Meryll Frost (co-captain in 1945), and Jules Alphonse.

JONATHAN JENKINS '49. Jon Jenkins, a 6-foot 2-inch, 210-pound tackle, had remarkable strength and was a pillar beside Dale Armstrong in Dartmouth's 1948 line. Jenkins was an All-New England and All-East selection and was captain of the North team in the 1949 Blue-Gray game. He went on to play pro football with the Baltimore Colts.

JOE SULLIVAN '49. Winner of the Bulger Lowe Award as New England's outstanding player in 1948, Joe Sullivan was Dartmouth's quarterback in 1947, halfback in 1948, and a solid defensive back throughout his career. In 1947, he passed for 510 yards. In 1948, he averaged 6.7 yards per carry rushing and threw only one pass, against Yale. Sullivan picked up a fumble and passed to Dale Armstrong for a 63-yard score. He still holds Dartmouth's record for interception return yards (112 on 11 thefts). He turned down a contract from the Detroit Lions to play defensive back in the NFL.

HERB CAREY '50. A 200-pound fullback and defensive back, Herb Carey was captain of the 1949 team. He joined the army right out of prep school and served in Europe. As a result, he was allowed to play as a freshman in 1946, joining his brother Art '45, a center who had also returned from wartime service.

JOHN CLAYTON '51. In an era when passing was not as prolific as it is today, John Clayton proved himself as one of the best of his day. Clayton replaced Joe Sullivan as Dartmouth's quarterback in 1948. Over the next three seasons, he completed 166 of 322 passes for 2,227 yards and 26 touchdowns. Clayton's career yardage total is 13th among Dartmouth's all-time passing leaders.

ELMER LAMPE. Elmer Lampe's introduction to Dartmouth was as an All-Big Ten end on the University of Chicago team, which lost to the 1925 national championship team. His long career in athletics brought him to Hanover as basketball coach in 1946 and as end coach for Tuss McLaughry. Lampe relinquished basketball to Doggie Julian in 1950 and continued as an aide to McLaughry and Bob Blackman until he retired in 1968, after sharing in McLaughry's postwar successes and those that came under Blackman.

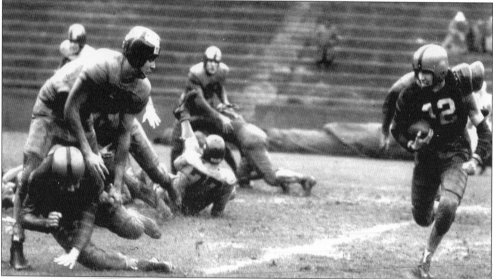

THE HURRICANE GAME. The final game of the 1950 season went down in history as the "Day of the Hurricane." Few remember it as the day Dick Kamzaier (42) led Princeton to the final win of an undefeated season. The blustery weekend left 278 dead and caused $400 million in property damage. Several other games were postponed, but Dartmouth met Princeton at Palmer Stadium. Pools of water dotted the field as Bob Tyler's 23-yard run gave Dartmouth the lead. Kazmaier and fullback Jack Davison gave Princeton a 13-7 lead at halftime that did not change.

Four

THE BOB BLACKMAN ERA
1955–1970

The Blackman era. The three words speak for themselves, a shorthand for the way one man and one college dominated Eastern football for parts of three decades. Bob Blackman coached for 16 years at Hanover, winning or sharing seven Ivy championships and creating three undefeated seasons. Three times he was named eastern coach of the year. Once he was national coach of the year. Twice his teams won the Lambert Trophy, emblematic of supremacy in eastern football. When his 1970 team won the trophy, Penn State coach Joe Paterno suggested a postseason playoff. Paterno, a Brown man, knew Dartmouth was prohibited from postseason play. Blackman said that if Dartmouth was going to break its (and the Ivy League's) longstanding practice of declining postseason play, it sure as heck would do it against a team with a better record than 7-3.

Blackman was a master recruiter, a master strategist (six of his assistants became head coaches), and a master motivator. His teams practiced in Yankee Stadium. They played with astonishing grace, skill, and power. They won nearly three times as many games as they lost. Blackman himself was the subject of fawning spreads in *Look* magazine and *Sports Illustrated*. He nearly left Hanover for the Big Ten after the undefeated season of 1965. Five years later, after his 1970 team finished ranked 14th in national polls, the lure was too great. He decamped for an unhappy tenure at Illinois, and then, having tasted failure for the first time, at Cornell, where he also failed to recapture the magic of his years in Hanover.

No matter. At Dartmouth, and in Blackman's heart, he was always a winner, always a Dartmouth man. He was always remembered for the swagger that was the personification of the confidence and success that imbued all of Dartmouth sports in that period. Football in the Ivy League owes more to Bob Blackman, who was inducted into the College Football Hall of Fame in 1987 and who died in 2000, than to any other man.

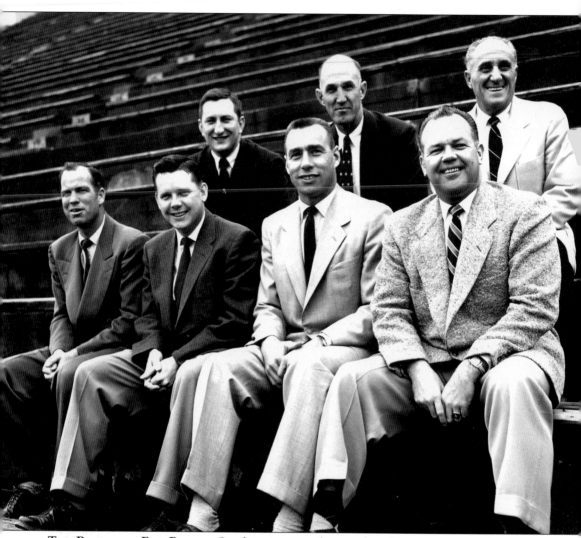

THE BLACKMAN ERA BEGINS. On the recommendation of Paul Brown, the NFL coaching legend whose son Mike '57 would be Dartmouth's quarterback in 1956, Bob Blackman came to Hanover from the University of Denver. A bout with polio ended his playing career after one year at Southern California. He recovered and became student assistant coach. He had winning records and championships at every stop—the U.S. Navy, Monrovia High School (in Monrovia, California), and Pasadena City College—and a 12-6-2 record in two seasons at Denver. Blackman (seated at right front) brought three able assistants to Hanover in 1955. They are, from left to right in the front row, Jack Musick, Earl Hamilton, and Will Volz. The Dartmouth links are, from left to right in the back row, Ray Truncellito '49, a guard on the 1947 and 1948 teams; Elmer Lampe; and Doggie Julian, the basketball coach with a long football background.

ART AND DUKE. Over four decades, Art Thibodeau (left) and Alfred "Duke" Duclos (right) dispensed equipment and wisdom to Dartmouth football players. Thibodeau arrived in 1926, Duke a decade later. They heard "confessions" after a practice that did not go well and provided reassuring counsel—that is, after Duke had deflated overblown freshman egos with a scowl and the taunt, "You're too small to play for Dartmouth. You should be at Harvard."

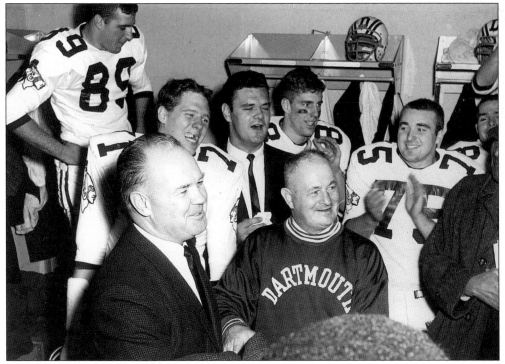

DUKE. By the time he retired in the mid-1970s, Duke Duclos had mellowed a bit, although his look of satisfaction in the locker room for the achievement of "his boys" at Princeton after the undefeated season in 1965 could be deceiving. Duke's successor, Kurt Foshey, a U.S. Air Force retiree, arrived in 1974. (His father had worked with Duke.) Foshey said, "I'll be here . . . until we have an undefeated football season." That happened in 1996, and Foshey retired soon after. Longevity is an equipment-room trademark at Dartmouth.

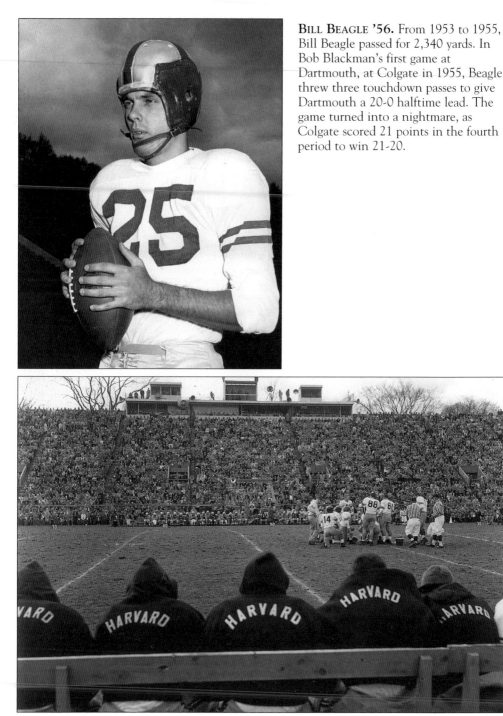

BILL BEAGLE '56. From 1953 to 1955, Bill Beagle passed for 2,340 yards. In Bob Blackman's first game at Dartmouth, at Colgate in 1955, Beagle threw three touchdown passes to give Dartmouth a 20-0 halftime lead. The game turned into a nightmare, as Colgate scored 21 points in the fourth period to win 21-20.

HARVARD, 1955. Dartmouth was 0-4 under Blackman when Harvard came to Memorial Field for the first televised football game at Dartmouth (broadcast by CBS). In the first period, Bill Beagle's 25-yard pass to Monte Pascoe gave Dartmouth the lead, but at halftime Harvard led 9-7. In the final period, Beagle ran for the deciding touchdown and added his second extra point. He had a hand in every Dartmouth point, and Blackman had his first win.

JOE PALERMO '58. In 1956, Ivy League round-robin play was introduced. By 1957, Bob Blackman's veer offense was established, and Dartmouth, led by captain Joe Palermo (an All-America guard who also kicked extra points), was pursuing titles. The Green was 7-0-1 (a tie with Yale) heading to Princeton, which had lost to Yale and was 7-1-0. The Tigers won 34-14 and claimed the Ivy crown.

JAKE CROUTHAMEL '60. From 1957 to 1959, Jake Crouthamel earned his place as one of the Ivy League's all-time great running backs. He gained 1,763 yards rushing, which was a Dartmouth record for more than a decade. In 1958 and 1959, Crouthamel was All-Ivy and All-East. In 1959, he was an All-America second-team selection.

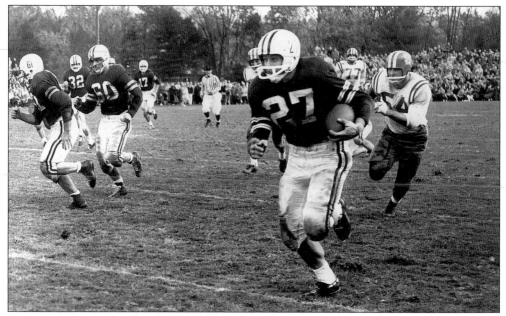

CROUTHAMEL IN MOTION. Over three seasons, Jake Crouthamel (27) averaged 4.6 yards per carry. He was later named to several all-time All-Ivy League teams. In 1960, he was drafted by the NFL's newest franchise, the Dallas Cowboys, and played briefly with the Cowboys and the Boston (now New England) Patriots. In 1965, he joined Bob Blackman's staff as backfield coach.

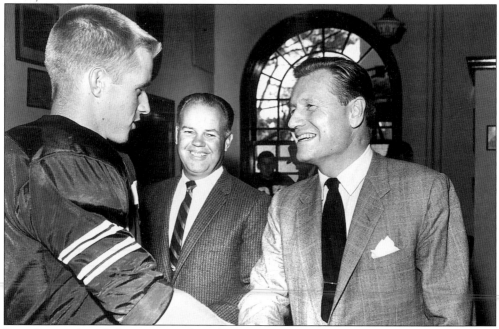

BILL GUNDY '60. Balancing Crouthamel's running, quarterback Bill Gundy passed for 1,138 yards and 16 touchdowns in 1958 and 1959. Here, with Bob Blackman's smiling approval, Gundy receives congratulations after a Dartmouth victory from Nelson Rockefeller '30, later the governor of New York and vice president of the United States.

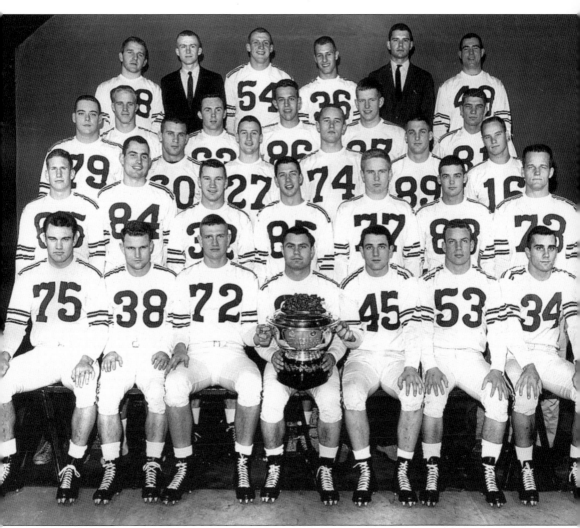

THE FIRST IVY LEAGUE CHAMPIONS, 1958. Captain Al Krutsch '59 holds the Ivy League trophy that came to Dartmouth for the first time in 1958. After coming close in 1957, the Green finished 6-1 (7-2-0 overall) in 1958. The lone loss was at Harvard; a key win was against Penn 13-12 in the second game, and the clincher was at Princeton 21-12. From 1957 to 1959, Dartmouth finished 2-1-2 in the Ivy standings. In 1959, the Green lost only to Penn in Ivy games. The Quakers, losers to Harvard, took the title by a half-game when Dartmouth played to a scoreless tie with Brown.

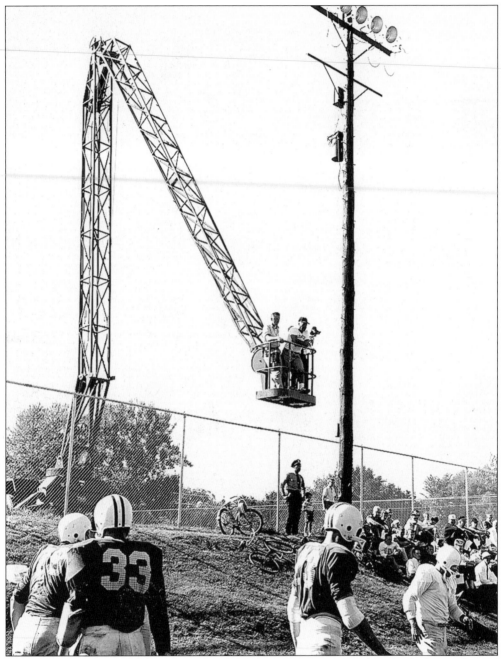

SKYBOX SEATING. As Dartmouth prepared for the 1962 season, coach Bob Blackman showed his imagination and opportunism as a coach. To oversee practice, he took to the bucket of an extension ladder truck. The vehicle's normal role was for the construction and maintenance of Leverone Field House, the vaulted-ceiling home for indoor track and field as well as for indoor football practice, which cost $1.5 million when it opened in 1962.

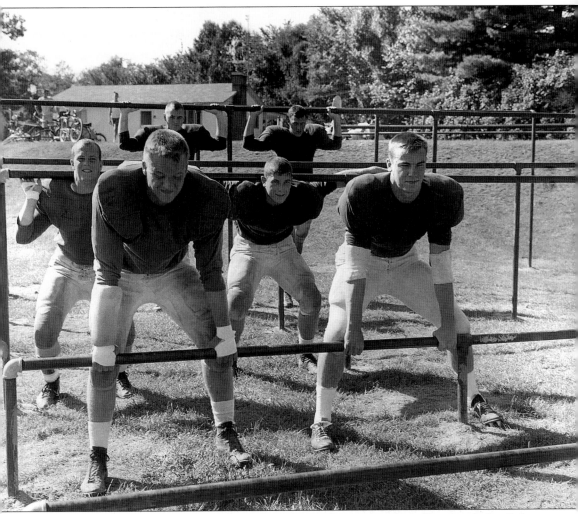

ISOMETRICS. Another training and conditioning tool introduced at Dartmouth by Bob Blackman in 1962 were isometric contraction bars positioned as the first stop for players arriving for practice on Chase Field. Testing the immovable objects are, from left to right, the following: (front row) guard Ed Boies '63 and halfback Tom Spangenberg '64; (middle row) tackle Dale Runge '64 and tackle Bill Blumenschein '63; (back row) center-linebacker Don McKinnon '63 and end Charley Greer '64. Throughout his career, Blackman built a reputation for innovation in coaching that became his trademark. More notably, he developed a nationwide recruiting program that was a decade ahead of his Ivy League coaching rivals.

THE DOGS OF DARTMOUTH FOOTBALL. For decades, dogs that were fraternity or Hanover community pets became a routine "delay of game" presence at Memorial Field. It was rare that a game did not include at least one—and usually several—"Dartmouth dog" moments. However, not every dog was interested in interrupting play as the game progressed. As players and coaches watched the action during Dartmouth's 10-0 win over Holy Cross in 1962, a dog of unknown origin drank from the players' water bucket and then calmly walked away. (AP Wire photograph, used with permission.)

BILL KING '63. Captain of Dartmouth's undefeated team in 1962, quarterback Bill King was described by Bob Blackman as "a coach on the field, about as important to me as my right arm." King completed 57 percent of his passes in 1962, including 14 of 16 (a completion percentage record of .875 that still stands) for 324 yards in a 42-0 rout of Columbia. He passed for six touchdowns and also ran for 523 yards and 14 touchdowns. King was twice the All-Ivy quarterback. He was also a third-team All-American (in 1962) and a defensive back.

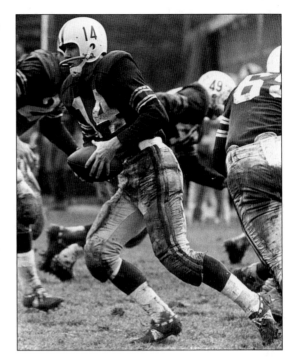

DON McKINNON '63. Center-linebacker Don McKinnon, shown making an interception during a 41-0 win at Brown, was named to two All-America first teams as a center in 1962. "Don could have played for any team in the country," said Joe Yukica, his line coach and later Dartmouth's head coach. "He was our Chuck Bednarik [Penn's postwar great], as valuable a two-way player as there was." McKinnon played for the Boston Patriots in 1963–1964.

KING AND McKINNON. Bill King (left) and Don McKinnon, at the 1962 team's championship banquet, showed their confidence during the 38-27 win at Princeton that capped the season. Fighting to hold a slim 31-27 lead, Bob Blackman called for a quick kick. "Tom Spangenberg, the quick kicker, refused to do it," said King, "and McKinnon agreed. Princeton's defense exposed their right side. I ignored Blackman's instructions, called for a sweep, and Tom ran for 29 yards." Ten plays later, Dartmouth scored. Said King, "Blackman never said a word. He encouraged us to think on our feet. He trusted us."

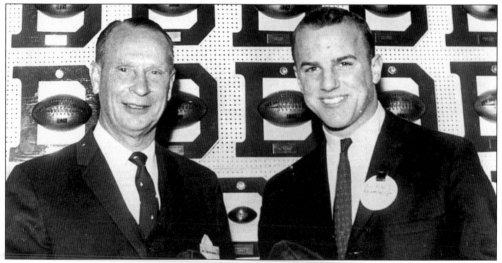

KING AND OBERLANDER. Thirty-seven years after Swede Oberlander (left) led Dartmouth to its first undefeated and untied season, Bill King led Dartmouth to its second. The celebration in 1962 included an invitation for living members of the 1925 team to share the moment and honor their matching rules for success: a great coach (Jess Hawley and Bob Blackman), mental and physical preparation, and the will to win. "They were true in 1925, they were true in 1962, and they're true to this day," King said 40 years later.

THE 1962 TEAM. In 1962, Bob Blackman borrowed an idea that Paul Dietzel had used to build a national champion team at Louisiana State in 1958, an idea that capitalized on Dartmouth's overall team depth and addressed the confusing substitution rules of the day. He broke the squad into three teams: Green (starters), Tomahawks (an offensive unit), and Savages (a defensive unit). The Green usually played more than half the game, but the Tomahawks and Savages played vital minutes as the team posted five shutouts, allowing only 57 points and scoring 236. In 1962, substitution was a bookkeeping nightmare for coaches and managers, but Blackman made it work to Dartmouth's advantage.

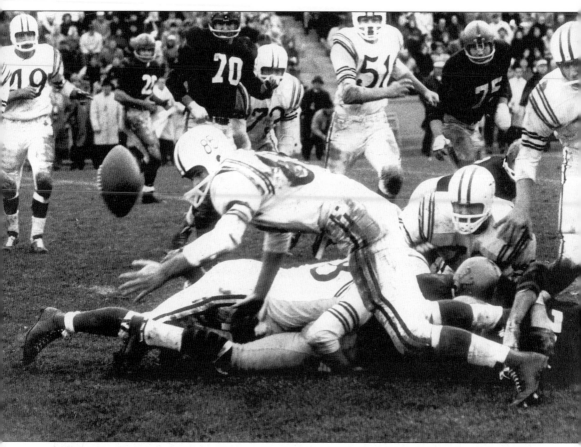

A DECISIVE FUMBLE, 1963. At Palmer Stadium in 1963, Princeton held a 21-15 lead when Dartmouth's defense hit Princeton tailback Cosmo Iacavazzi, forcing a fumble. Allin Pierce (85) swiped the ball back to Princeton's two, where Scott Creelman recovered. Jack McLean's run and Gary Wilson's kick gave Dartmouth a 22-21 win. Dartmouth and Princeton shared the Ivy League title with matching 5-2 league records. This photograph was taken by Heinz Kluetmeier '65 for Dartmouth sports information director Ernie Roberts. Since 1968, Kluetmeier has been an award-winning photographer for *Sports Illustrated*.

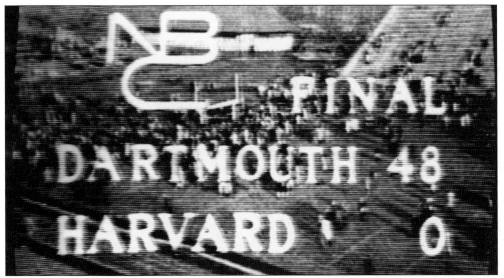

HARVARD, 1964. Riding a 15-game win streak in 1963, Dartmouth went to Harvard Stadium and was upset 17-13. In 1964, the Green returned to Cambridge and handed Harvard a payback that saw the Green dominate play with a withering offense and a scathing defense. The afternoon belonged to Dartmouth. NBC, which broadcast the game, etched the score of 48-0 onto television screens—and into the memory bank of Harvard-Dartmouth lore.

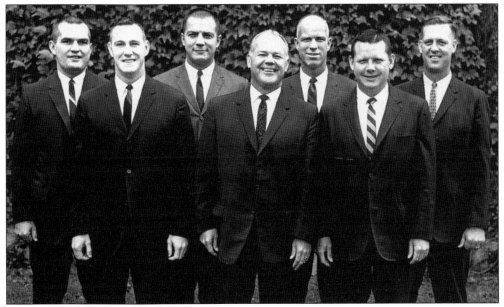

BLACKMAN'S 1964 STAFF. By 1964, there were several new faces on Bob Blackman's staff. Shown here are, from left to right, John Anderson, Neil Putnam, Joe Yukica, Blackman, Jack Musick, Earl Hamilton, and Jim Root. Over the following two decades, all but Hamilton moved on to become college head coaches. Hamilton, who came to Hanover with Blackman in 1955 and became a surrogate father for hundreds of Dartmouth players as the freshman football coach, was playing golf at the annual coaches' outing at Hanover Country Club in 1968 when he suffered a fatal heart attack. Two annual Dartmouth football awards are presented in his memory.

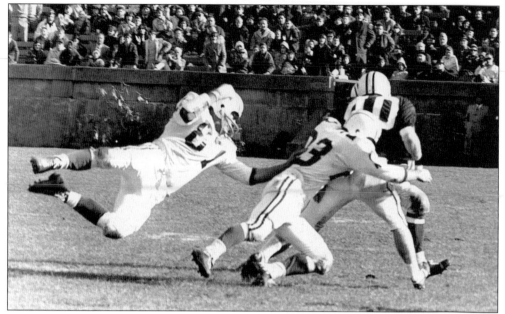

YALE, 1965. Yale teams under coach John Pont in 1963 and 1964 had beaten Dartmouth 10-6 and 24-15. In 1965, Pont had become head coach at Indiana. His successor was Carmen Cozza, who guided the Elis for the next 32 years. As Dartmouth built what became another undefeated season, the visit to Yale Bowl was one of the Green's closest calls. Yale, with a 2-3 record against 5-0 Dartmouth, built on its 1963 and 1964 successes and had a 17-13 lead in the fourth period. Above, Eli halfback Court Shevelson (40), a breakaway threat that day, is brought down by Andy Danver (23) and Tom Clarke (87). Below, fullback Pete Walton powers over Yale's Chris Beutler for the touchdown that gave Dartmouth a 20-17 win. Statistically, Yale won everything except the final score.

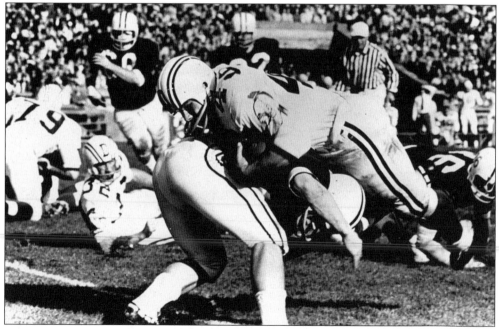

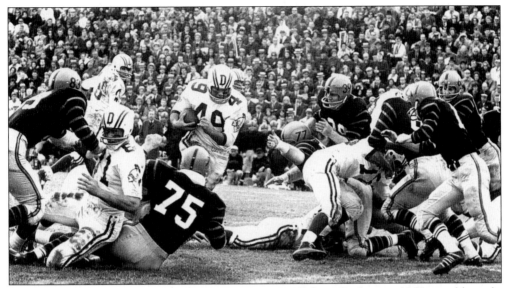

PRINCETON, 1965. The Dartmouth-Princeton game at Palmer Stadium in 1965 arguably ranks as the most memorable game in Dartmouth football history. Princeton had not lost a game since the 1963 finale with Dartmouth and was riding a 17-game win streak. Dartmouth was 8-0. A crowd of 45,725 came to watch the battle for the Ivy League title and the mythical Eastern championship. They were not disappointed; at least Dartmouth fans were not. As seen above, Dartmouth's offensive line gave gaping holes to fullback Pete Walton, the Green's leading scorer (60 points) and runner (641 yards) in 1965. Seen below is the play that was the *coup de grâce* in a 28-14 win. With Dartmouth leading 21-7 early in the fourth period, quarterback Mickey Beard launched a pass that end Bill Calhoun (81) caught at midfield. Calhoun, not the primary receiver on the play, raced past Princeton's defenders to complete a 79-yard scoring play. Calhoun said, "I didn't know if anyone was behind me. I just kept running for that goal line."

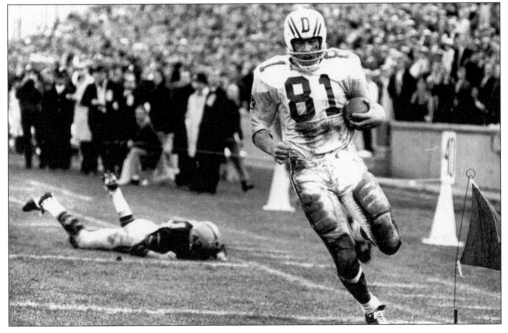

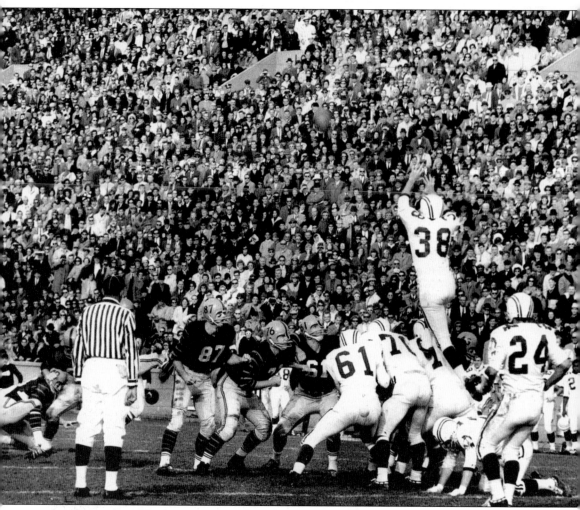

AIRBORNE: SAM HAWKEN '68. It is illegal today, but in 1965 Dartmouth's "human steps" play was the brainchild of assistant coach Jack Musick. While it misfired, the play made the Princeton players wonder, "What will these guys do next?" While scouting Princeton, Musick learned from small talk with a Princeton manager that Charlie Gogolak, one of the Ivy League's greatest kickers, always aimed over the right guard. The play was practiced, and six-foot two-inch sophomore back Sam Hawken, wearing cross-country shoes, was charged with climbing the steps and vaulting to block Gogolak's field goal attempt. Unfortunately, Hawken leaped too soon and was offside. Gogolak, now rattled, scuffed his next attempt. In a "most memorable" game, this may be the most memorable play in Dartmouth football history.

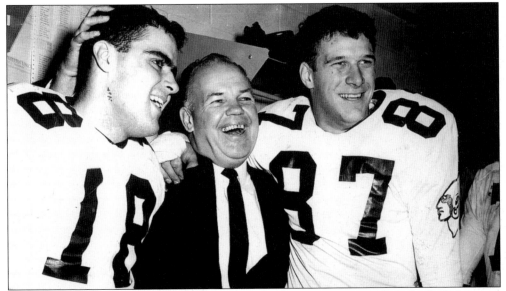

CHAMPIONSHIP SMILES. Bob Blackman, whom Yale coach John Pont called "football's happiest sad man," had reason to revel in the aftermath of the 1965 finale at Princeton. So, too, did quarterback Mickey Beard '67, seen here at the left. His two one-yard dives gave Dartmouth a 14-7 halftime lead, and his 79-yard pass play with Bill Calhoun clinched the win. Also celebrating here is Tom Clarke '66, the captain and All-Ivy defensive end of the East's best team in 1965.

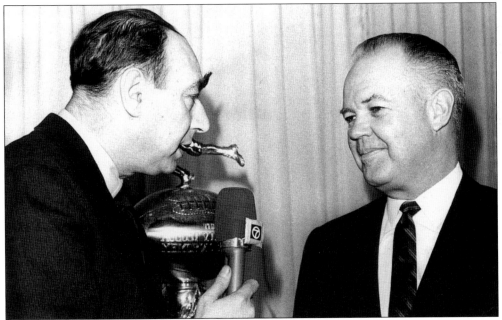

JUST REWARDS. After Dartmouth had beaten Princeton in 1965, New Jersey columnist Bus Saidt wrote, "If Dartmouth does not get the Lambert Trophy (as the Eastern champion), it should demand an investigation by a Senate committee." No investigation was necessary; Dartmouth was the Lambert winner. At the presentation ceremony in New York, Bob Blackman waited patiently to reply to the observations of outspoken sportscaster Howard Cosell.

DARTMOUTH'S DISTINCTIVE HELMET. In 1965, Bob Blackman sought a unique source of pride that would immediately identify Dartmouth's successful football team. He came up with the helmet design featuring parallel stripes and the block "D" that became as much of a trademark as Michigan's famed "winged" helmet. The design was used from 1965 to 1986, when coach Buddy Teevens sought a "fresh start" after four losing seasons and changed the helmet design. In 1999, coach John Lyons restored the design that symbolized "Blackman magic."

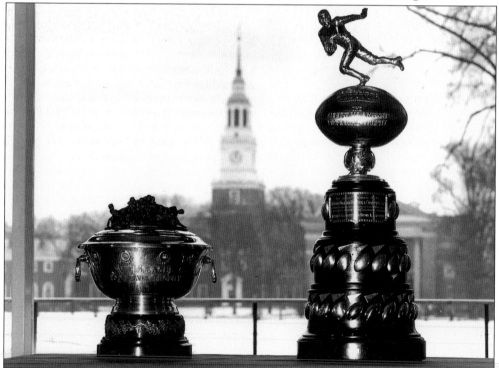

THE PRIZES. The Ivy League Football Trophy (left) has resided in Dartmouth's hands 17 times, more than any other team. Also, as the Eastern major college champion in 1965 and 1970, Dartmouth joined Princeton (1950, 1951) and Yale (1960) as the Ivy teams to claim the Lambert Trophy. With the Ivy League now playing at the NCAA Division 1-AA level, Ivy teams are no longer eligible for the Lambert Trophy.

UNDEFEATED IVY LEAGUE AND EASTERN CHAMPIONS, 1965. After waiting 37 years for its second undefeated team, Dartmouth needed only three years to get number three. The Green's 9-0-0 record had one All-American—defensive end Ed Long '66, who made the Associated Press second team. Long was one of 19 members of the 1965 team who received some level of All-Ivy, All-New England, or All-East recognition. For the third time in a decade, Boston football writers named Bob Blackman the New England coach of the year. After New Year's Day in 1966, when Michigan State, Arkansas, and Nebraska were beaten in bowl games, Dartmouth remained the only undefeated major college football team in the land.

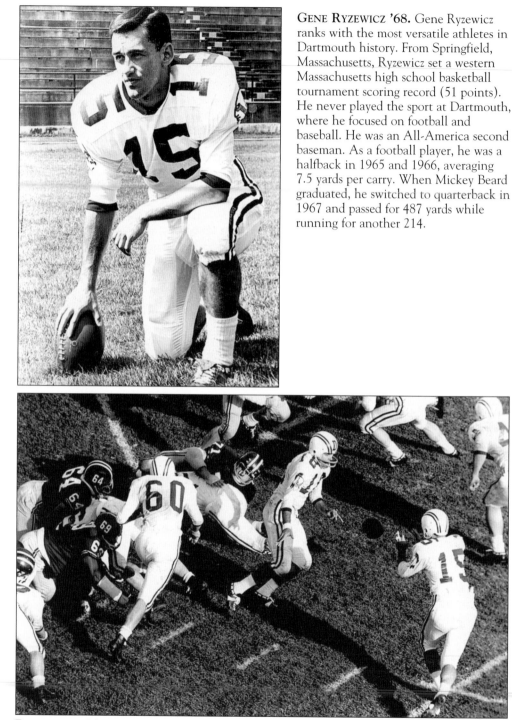

GENE RYZEWICZ '68. Gene Ryzewicz ranks with the most versatile athletes in Dartmouth history. From Springfield, Massachusetts, Ryzewicz set a western Massachusetts high school basketball tournament scoring record (51 points). He never played the sport at Dartmouth, where he focused on football and baseball. He was an All-America second baseman. As a football player, he was a halfback in 1965 and 1966, averaging 7.5 yards per carry. When Mickey Beard graduated, he switched to quarterback in 1967 and passed for 487 yards while running for another 214.

RYZEWICZ IN MOTION. At Harvard in 1966, Gene Ryzewicz took a toss from Mickey Beard and scored to give Dartmouth a 14-7 lead in the third period. It did not last. Harvard scored twice in the last period to win 19-14. While Ryzewicz was a major contributor to Dartmouth's 23-4 record from 1965 to 1967, he dealt with injuries and was never an All-Ivy first-team selection.

HANK PAULSON '68. Hank Paulson became a sophomore starter at tackle in 1965 and led the Green in minutes played. A three-year starter, Paulson was a first-team All-Ivy, All-New England, All-East choice and an honorable mention All-American as a senior. An NCAA Scholar-Athlete, Paulson's career in investment banking led to his becoming chief executive of Goldman Sachs. In 2000, he made a gift to Dartmouth that endowed the head football coaching position in memory of Bob Blackman, who had died earlier that year.

GORDON RULE '68. The leader of Dartmouth's defensive secondary in 1967, Gordie Rule duplicated Hank Paulson's All-Ivy, All-New England, All-East, and All-America honors. A three-year regular with six career interceptions, Rule was taken by Green Bay in the 1968 NFL draft and played two seasons with the Packers.

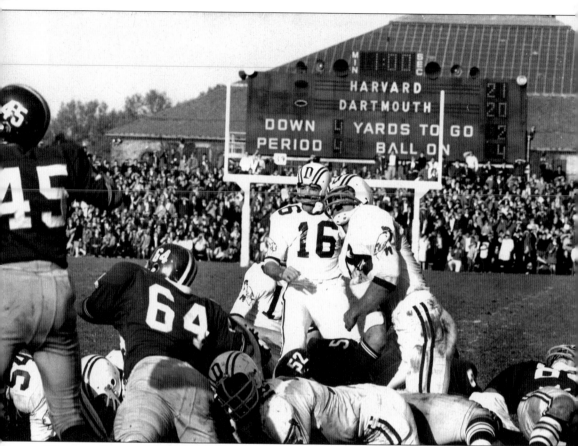

"Second Chance" Pete Donovan '70. Team statistics say Pete Donovan (16) was 4-4 in field goals as a sophomore in 1967. The stats do not tell the tale of Donovan's "second chance" 21-yarder that came after Harvard was penalized on his first attempt, which missed. The crucial kick came after Harvard had rallied from a 20-0 deficit to lead 21-20 with a minute to play. Another Donovan field goal capped a 17-14 win at Princeton later in the season. Also a defensive back, Donovan was the All-Ivy kicker in 1969 when he made 35 of 36 conversions and led Dartmouth in scoring with 53 points.

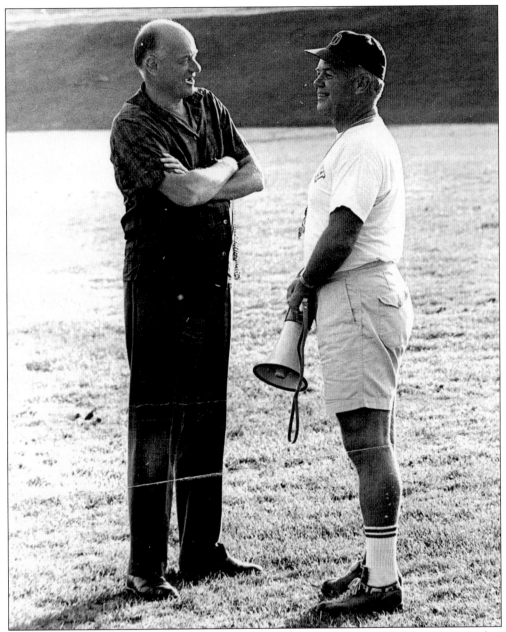

JOHN SLOAN DICKEY '29. As Dartmouth's president from 1945 to 1970, John Sloan Dickey was a guiding force in the creation of the Ivy League, from the signing in 1945 of a football agreement among the eight members—Brown, Columbia, Cornell, Dartmouth, Harvard, Pennsylvania, Princeton, and Yale—that set eligibility standards and banned athletic scholarships and postseason games. The Presidents' Agreement of 1954 formalized the pact, paving the way for round-robin competition that began in 1956. During the 1960s, when Dartmouth, Harvard, Yale, and Princeton were frequent participants in the limited schedule of football telecasts, Dickey promoted a plan for equitable distribution of television income among all Ivy League members. Throughout his tenure as president, Dickey (shown here with Bob Blackman in 1968) made a point of fitting regular visits to football practice into his schedule.

WILLIE BOGAN '71. In 1968 and 1969, Bob Blackman scheduled preseason scrimmage games with Boston College, a New England power coached by his former assistant, Joe Yukica. Dartmouth won 21-15 in 1968. A year later, Willie Bogan (43) had two interceptions, including this 42-yard return to a touchdown. Dartmouth won 42-6. It was a scrimmage with pride and bragging rights on the line as Dartmouth sent a message that it would have a good team in 1969.

SUPERB SECONDARY. Dartmouth's defensive secondary in 1969 reflected the reach of Bob Blackman's national recruiting program to find outstanding student-athletes. Seen here are, from left to right, Russ Adams '71 of New Wilmington, Delaware; Jack Roberts '70 of Stevens Point, Wisconsin; Joe Adams '70 of Muleshoe, Texas; and Willie Bogan '71 of Albion, Michigan. In 1969, Russ and Joe Adams were All-Ivy, and Joe was an All-East and honorable mention All-American. In 1970, Bogan was All-Ivy, All-East, and an NCAA and National Football Foundation scholar-athlete who was also named as a Rhodes scholar.

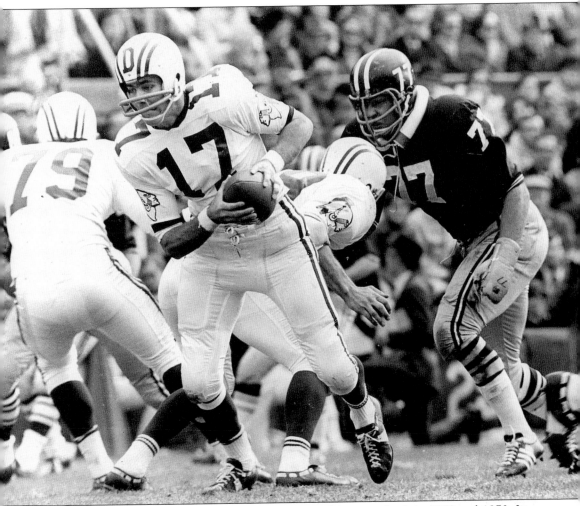

JIM CHASEY '71. During his two seasons as Dartmouth's quarterback in 1969 and 1970, Jim Chasey led the Green to 17 wins in 18 games. A deft passer and option runner, Chasey orchestrated a nationally ranked attack that averaged 33 points per game. His consistency in picking apart defenses makes it impossible to select his best game. Except for the collective debacle at Princeton in 1969, Dartmouth's lone loss over two seasons, Chasey was virtually flawless. His career total of 2,391 yards passing was built with a .571 completion percentage. From Los Gatos, California, Chasey was twice voted the All-Ivy first-team quarterback. The Asa Bushnell Cup, awarded for the first time in 1970 to the Ivy League's outstanding player, was shared that year by Chasey and Cornell tailback Ed Marinaro. Chasey later played for several seasons in the Canadian Football League.

YALE, 1969. In 1967 and 1968, Yale's outstanding teams, led by quarterback Brian Dowling and tailback Calvin Hall, pounded Dartmouth 56-15 and 47-27. In 1969, Dartmouth returned the favor. Senior halfback Tom Quinn (24), shown leaping for yards against the Elis, was a key contributor. With Yale leading 14-7 in the second period, Quinn uncorked a 33-yard option pass to end Bob Brown '71 that launched Dartmouth to a 28-14 lead. In the fourth period, Quinn electrified the crowd of 49,958 at Yale Bowl with a 54-yard punt return that iced a 42-21 win.

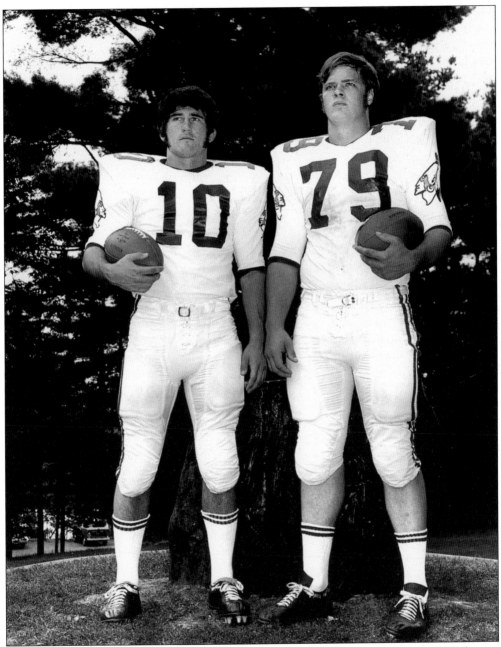

THE 1970 CAPTAINS. Dartmouth's 1969 season closed with an uninspiring 35-7 loss at Princeton that left the Green with an 8-1 record and a three-way tie for the Ivy League title with Yale and Princeton. "That game was embarrassing," said Murry Bowden '71 (10), who was co-captain with Bob Peters '71 in 1970. "It was 35-7 but it seemed like 50-7. Football is an emotional sport and we didn't want that to happen again. We maintained a fever pitch throughout the 1970 season." Bowden, the defensive rover back from Texas, became an All-American. Peters, an offensive tackle from Illinois, was All-Ivy, All-New England, and All-East. They led what ranks as perhaps the greatest team in modern-day Ivy League football.

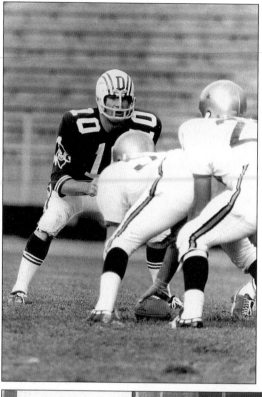

"ACCELERATE THROUGH IMPACT."
Murry Bowden's intensity on the football field energized his teammates. He described his method: "Accelerate through impact . . . hit them through the back of the front of their chest. It was a hallmark of playing aggressively and it served me well." Indeed it did, even though he played with surgically repaired knees and shoulders. He certainly could play football, though he could not play tennis or throw a snowball.

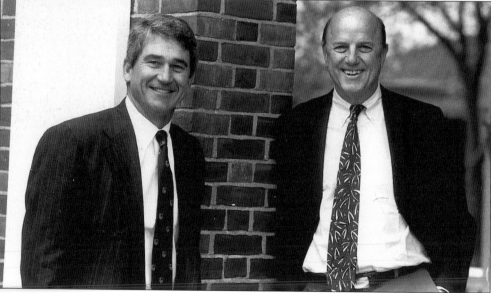

UNDEFEATED TEAM LEADERS. Seen here at a meeting in Hanover long after their playing days were done, Dartmouth captains of undefeated teams in 1970 and 1962—Murry Bowden (left) and Bill King—have carried their leadership qualities far beyond the football field. Bowden, elected to the Football Hall of Fame in 2003, is a Houston-based real estate developer who has become a Dartmouth alumni leader. King, a lawyer in Richmond, Virginia, recently completed his service as chair of Dartmouth's board of trustees.

84

GOING TO BATTLE. Until the mid-1970s, most Dartmouth-Harvard games were played before crowds of more than 30,000 at Harvard Stadium. It often felt like a home game for Dartmouth, especially when the Green approached the stadium through energized Dartmouth fans. In 1970, Bob Blackman and Murry Bowden (10) savored the walk, which was rewarded with a 37-14 win over the Crimson. It was Blackman's 100th victory at Dartmouth. When the season was complete four weeks later, Blackman had a 15-year record of 104-37-3 at Dartmouth, his third undefeated team in nine seasons, and no more Ivy League mountains to climb. As with Earl Blaik, Blackman's heart remained in Hanover, though he moved on to coach at Illinois and then at Cornell. He retired in 1982 and was elected to the Football Hall of Fame in 1987.

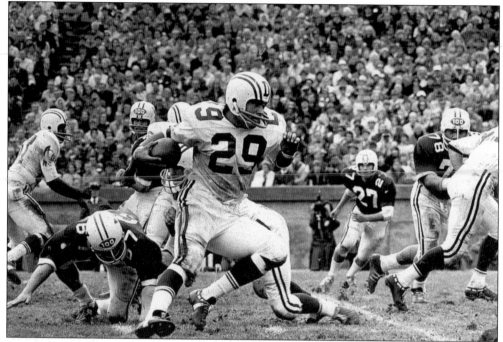

JOHN SHORT '71. Halfback John Short was All-Ivy in 1969, when he ran for 707 yards and averaged six yards per carry. He was second-team All-Ivy in 1970, even though he set a Dartmouth season record with 787 yards rushing, added 395 yards receiving, and led the undefeated Green with 90 points, the fourth-best point record ever at Dartmouth. During three varsity seasons, the 200-pounder from Arizona had 1,589 yards rushing and 415 yards in kickoff and punt returns.

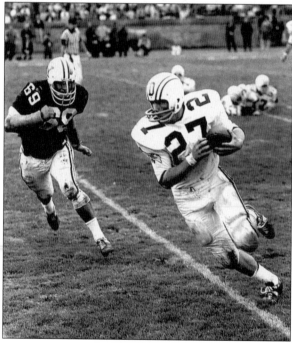

BRENDAN O'NEILL '72. Worcester sportswriter Roy Mumpton called Dartmouth's 10-0 win at Yale in 1970 "the most lopsided 10-0 win in Ivy League history." The Green had a 480-190 advantage in total yards. The most important three yards came on Brendan O'Neill's sprint for the game's only touchdown. O'Neill, John Short's backup at halfback, led the Green with 77 rushing yards in a game with previously unbeaten Yale, signaling that Dartmouth would not lose in 1970.

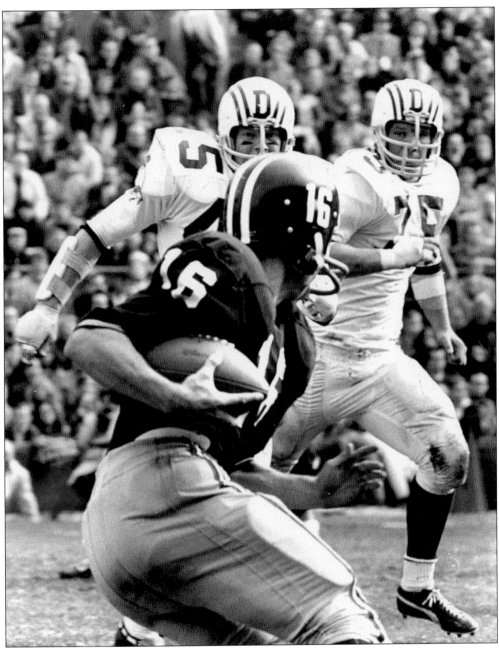

DEFENSE. The 1970 team averaged 34.5 points per game. Just as impressive was the Green defense, which shut out six of nine opponents, the most for a Dartmouth team since 1909, and allowed only six touchdowns all season. Taking their cue from Murry Bowden's leadership, Dartmouth's defenders led the nation in scoring defense with plays like this one, in which linebacker Joe Jarrett '71 (45) and All-East tackle Barry Brink '71 (75) presented a stone wall for Harvard's Ray Hornblower. Dartmouth did not allow a point after the Harvard game. The most memorable moment came in the finale at Penn when the Quakers moved to Dartmouth's seven-yard line in the second period. Three Penn plays lost 15 yards, and a 42-yard field goal sailed wide right. Dartmouth won 28-0.

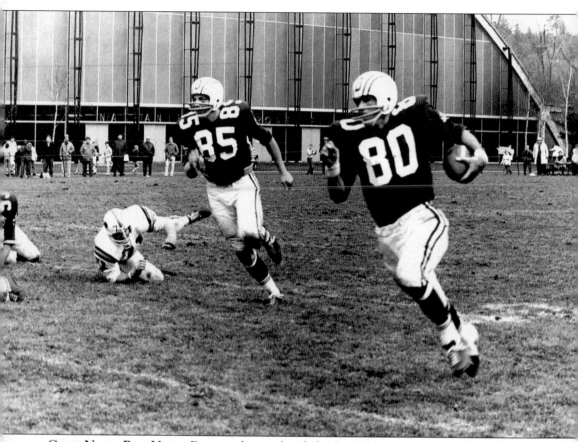

GOOD NEWS, BAD NEWS. Dartmouth was already leading Columbia 41-0 in 1970 when Bob Blackman called an end-around "alumni play" against the beleaguered Lions. Bob Brown (80) swept left. With tight end Darrel Gavle (85) providing convoy support, Brown cruised 39 yards to score. Speedy Tim Copper added a 64-yard punt return and Dartmouth won 55-0. That is the good news. In 1971, "55-0" became a rallying cry for Columbia. The Lions had their best team in a decade. When Dartmouth brought a 15-game win streak to Baker Field, Columbia built a 28-14 lead. Dartmouth rallied to move ahead 29-28. With 43 seconds to play, Paul Kaliades kicked a 34-yard field goal. Dartmouth's 31-29 loss in 1971 was as painful as Columbia's 55-0 loss in 1970.

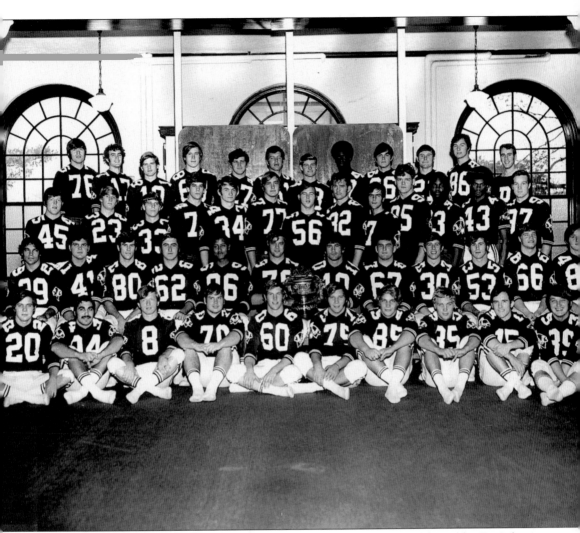

THE 1970 TEAM. Winners of the Ivy League title and the Lambert Trophy as the East's best team, Dartmouth's 1970 team was the last Ivy League team to finish in the national major college rankings. Both the AP and UPI polls voted Dartmouth 14th. (Joe Paterno's Penn State team was 18th and 19th.) In the annals of Ivy League football, no team has displayed comparable dominating balance. The Green led the nation in scoring defense and was second in total defense, third in rushing defense, and fifth in pass defense. Dartmouth was also sixth in both scoring and total offense and was ninth in rushing. Nineteen players received regional and national recognition. As the national championship team did in 1925, the 1970 team also produced a Rhodes scholar; Willie Bogan joined Nate Parker '26 in that prestigious honor. While it marked an end to the Bob Blackman era in Hanover, the 1970 team stands as the centerpiece of a five-year period when Dartmouth dominated Ivy League football.

GIFF FOLEY '69. Shown with director of athletics Seaver Peters, Giff Foley (left) brought a different kind of leadership to Dartmouth's 1970 team. He came to Hanover in 1965—on a motorcycle—and won an All-Ivy mention as a defensive tackle in 1967. His free spirit did not endear him to the college deans. Foley left Dartmouth for the Marine Corps and Vietnam, where he won the Silver Star and a Purple Heart. He returned to Dartmouth and football in 1970 and accepted a reserve's role, providing behind-the-scenes leadership and building poise and confidence that came from his experiences. After Dartmouth, he combined a business career with a love for flying. In 1990, while doing barrel rolls at an air show near Buffalo, his plane plunged into the Niagara River. His friend Prof. Jeffrey Hart '51 quoted Yeats: "Soldier, scholar, horseman, he. . . . What made us dream that he could comb grey hair?"

Five
THE TRADITION CONTINUES
1971–2003

In society as in sports, the period from 1971 to 2003 was one of great transformation. In those years, college football changed substantially. Like its players, it became faster, bigger—and more troubled. But while football changed a lot, the Ivy League did not. That would be its curse and its charm.

The crowds were slimmer, the national profile smaller (the Ivy League moved from Division 1-A to 1-AA), but it still mattered if Dartmouth beat Harvard. It mattered to no one on earth more than it did to Jake Crouthamel '60, Bob Blackman's successor and the architect of three consecutive Ivy championships himself. Like Blackman, Crouthamel, who left coaching and served for more than a quarter-century as athletic director at Syracuse (he was one of the founding fathers of the Big East Conference), spawned a Dartmouth diaspora of football leaders: head coaches Jerry Berndt, Rick Taylor, and Tom Kopp; NFL scout Dub Fesperman; and Drew Tallman, an author of books on football strategy. Crouthamel was followed by Joe Yukica, who won three Ivy crowns; by Buddy Teevens '79, who coached two consecutive Ivy championships; and by John Lyons, the current coach, who has won two Ivy crowns and who crafted Dartmouth's only 10-0-0 season. Dartmouth is the only place to make an unusual claim. Every one of its football coaches since the beginning of formal Ivy play has won at least two Ivy crowns.

This period was full of memorable rivalries, including the return of regular contests against Colgate and the suspension and later restitution of the rivalry with New Hampshire. But mostly, the period was full of memorable players of impact on and off the green fields of autumn. Reggie Williams '76 played in two Super Bowls, was a civic leader in Cincinnati, and was a *Sports Illustrated* man of the year. Teevens was later the head coach at Tulane and Stanford. Dave Shula, a gifted end, followed his father as an NFL coach, and quarterback Jeff Kemp '81, like his father, was an NFL quarterback. Quarterback Jay Fiedler '94 and two veterans from the 1996 undefeated season, Lloyd Lee '98 and Zack Walz '98, went on to the NFL. Tight end Casey Cramer '04 became Dartmouth's most recent All-American. After more than 120 years, at Dartmouth, football still matters most.

A NEW ERA, 1971. When Bob Blackman left Dartmouth in 1970, the challenges for his successor were not unlike those facing the coaches who succeeded John Wooden when he retired after years of championship basketball at UCLA. Jake Crouthamel, who played for Blackman and had been an assistant coach at Dartmouth since 1965, accepted the "no-win" opportunity. John Curtis, who also joined Blackman's staff in 1965, stayed on as well. The rest of the staff was new to Dartmouth and the Ivy League. Seen here are, from left to right, the following: (front row) Dub Fesperman, Tom Kopp, Crouthamel, Drew Tallman, and John Curtis; (back row) Rick Taylor, Jerry Berndt, Dennis Brown, and Jim Attaway. What would they do for an encore? They continued the dominating run with three more Ivy League titles.

TWO FACES OF JAKE. As Dartmouth's football coach, Jake Crouthamel's cup seemed always half-empty. The pleasure of victory was short lived, the pain of defeat enduring. Above, he relaxes prior to the 1971 season with Ned Martin, the Boston Red Sox broadcaster who did radio play-by-play of Dartmouth football in the late 1960s and early 1970s, reaching throughout New England on the Beacon Sports Network. Below, Crouthamel is in his own world outside the locker room at Massachusetts before his first game as a head coach. At halftime, Dartmouth led 28-0 and won 31-7. A win streak, launched in 1970, continued.

Co-Captains, 1971. Linebacker Wayne Young '72 (left) and fullback Stuart Simms '72, Dartmouth's leaders in 1971, knew the taste of victory. Both were two-year starters in 1969 and 1970 and, in reality, were more familiar with Dartmouth football than all the coaches except Jake Crouthamel and John Curtis. Young had played beside Murry Bowden in the middle of Dartmouth's defense and had fed on Bowden's energy. He had seven career interceptions. Simms, at 215 pounds, spent his third season as a durable runner (854 career yards), but he was even more valuable as a crushing blocker. The most important things that Young and Simms brought to this team were confidence and an expectation of victory. Young said, "The guys who followed Murry passed on his spirit. The three Ivy champions that followed the 1970 team owed a lot of their success to the pride he generated in Dartmouth football."

94

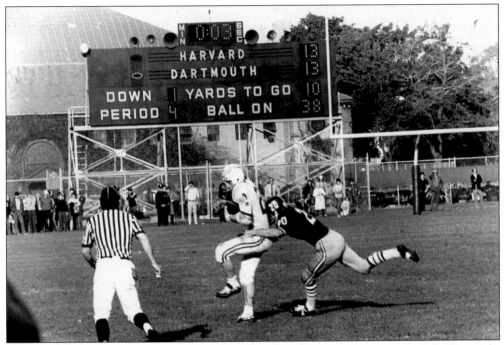

HARVARD, 1971. The visit to Harvard Stadium in 1971 was the second of three straight Dartmouth games decided by a Ted Perry '73 field goal. At Brown, Dartmouth won 10-7. A week later, Perry's kick toppled Yale 17-15. But neither compared to the 16-13 win at Harvard. After three periods, the score was 13-13. In the last three minutes, the ball changed hands six times. Dartmouth's opportunity came when Wesley Pugh '73 intercepted a pass and ran to Harvard's 38 with six seconds to play. Above, senior Bill Pollock's nine-yard pass has found Doug Lind '74, who will drag Harvard's defender out of bounds with two seconds left. Below, Perry tests the wind and will drive a 46-yard field goal, leaving the crowd of 33,500 to ponder the implausible finish.

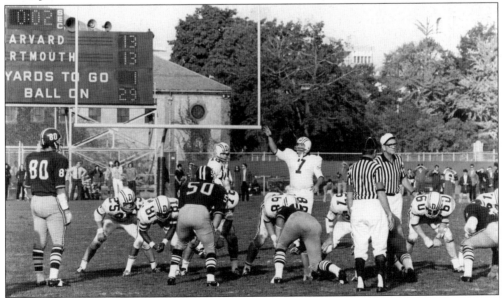

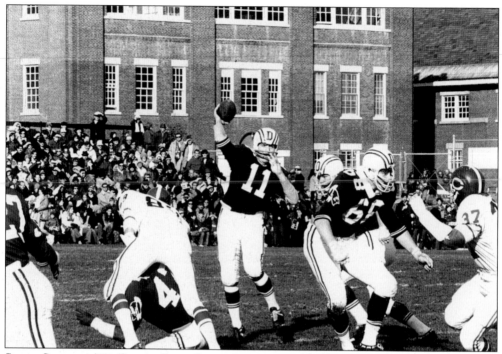

STEVE STETSON '73. Despite Steve Stetson's two second-half touchdown passes, Dartmouth's 15-game win streak ended at Columbia. A week later, Stetson was the starter, but tailback Ed Marinaro of undefeated Cornell was the presumed story at Memorial Field. Stetson ran for one score as Dartmouth built a 17-0 lead. Marinaro led Cornell back, scoring twice. Dartmouth led 17-14 when Stetson passed to end Tyrone Byrd '73 for the clincher 24-14. A week later, Dartmouth beat Princeton 33-7, leaving the Green and Cornell as Ivy co-champions.

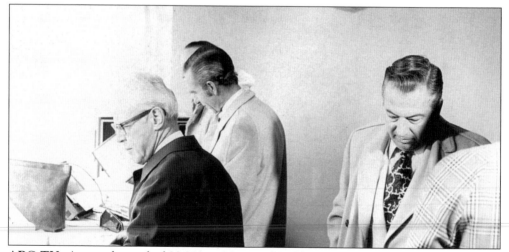

ABC-TV. A record crowd of 20,819 at Memorial Field was joined by an ABC-TV regional audience for the Cornell-Dartmouth game. Cornell tailback Ed Marinaro, a Heisman Trophy candidate, ran 44 times for 177 yards. However, ABC-TV's top college football broadcast team—Bud Wilkinson, Chris Schenkel, and Bill Fleming, seen here from left to right—tapped Dartmouth quarterback Steve Stetson as its player of the game.

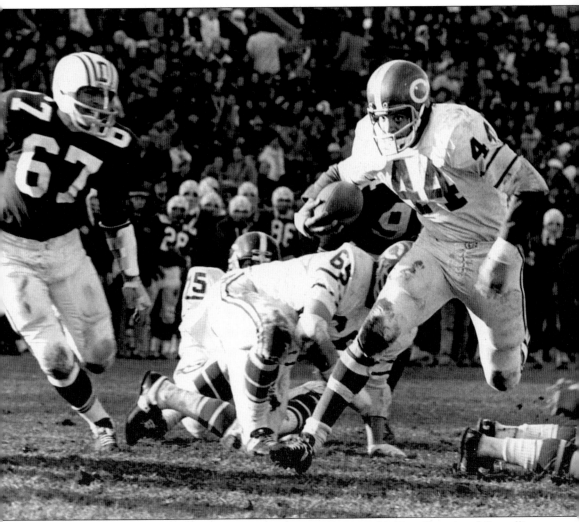

TOM CSATARI '74 AND ED MARINARO. By any measure, Dartmouth's Tom Csatari and Cornell's Ed Marinaro were dramatic contrasts. The only time they met in football was at Memorial Field in 1971, when Csatari (67) was a 185-pound sophomore defensive end and Marinaro, a 210-pound tailback, was completing his career as the Ivy League's all-time rushing leader. When their Ivy League careers were complete, Marinaro was twice voted the Ivy League player of the year, but his teams were 0-3 against Dartmouth. Csatari's teams were 3-0 against Cornell. The common denominator was that both were three-time All-Ivy first-team selections.

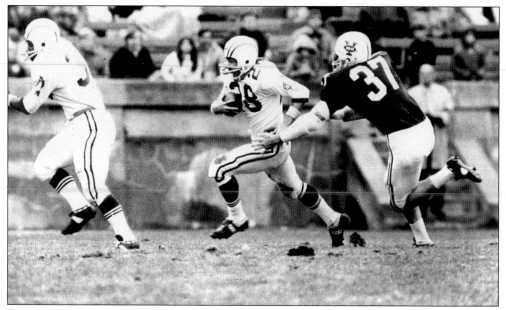

RICK KLUPCHAK '74. Speed to the corners makes all the difference in a running game, and Rick Klupchak (28) had it. Jake Crouthamel described a punt return for a touchdown as "the prettiest play in football." In a 1971 preseason scrimmage with Vermont, the sophomore from Illinois returned a punt 94 yards to score. In Dartmouth's opener at Massachusetts, he got most of his 134 yards rushing on an 82-yard burst. He also scored on a 24-yard pass from senior Bill Pollock, an eye-catching start to a three-year career in the Green backfield.

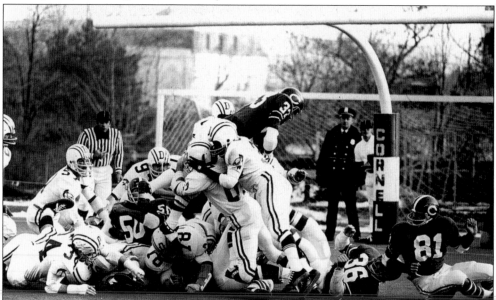

GOAL LINE STAND AT ITHACA. Dartmouth needed a win to stay atop the Ivy League in its eighth game of the 1972 season. The Green made two dramatic goal line stands in the second half, including this stop of Cornell tailback Horace Bradshaw inside the one-yard line that preserved a 24-22 lead. Moments later, Rick Klupchak broke a 72-yard run to seal a 31-22 win that spurred Dartmouth toward its fourth straight Ivy League title.

GOLD-PLATED DEFENSE. In 1973, Harvard was 4-0 and Dartmouth was 1-3 when they met in the Stadium. The underdog Green built a 24-3 lead at halftime. Then, sandwiched inside two Crimson scores, Dartmouth's defense—nicknamed "the Misfits"—produced three great goal line stands that preserved a 24-18 win. Coach Jake Crouthamel called it "one of the greatest wins in Dartmouth history." Senior rover back Rick Gerardi '74 (35), who made several tackles for losses, described the battle to Boston sportswriters, including, in the left foreground, the *Boston Globe*'s great columnist Ray Fitzgerald. Elsewhere in the locker room at Harvard, co-captain and guard Herb Hopkins '74 said, "This is a championship team. When championship teams have to perform, they perform." From an 0-3 start, Dartmouth finished 6-3 and won its fifth straight Ivy championship with a 6-1 league record.

A RUSHING RECORD. Rick Klupchak (28), shown with running mate Doug Lind, came into the 1973 season with 1,388 yards rushing but missed several games with an injury. He needed only 376 yards to break the Dartmouth career rushing record of 1,763 yards set by his coach, Jake Crouthamel, from 1957 to 1959, but through seven games he had gained only 118 yards; Lind and fullback Ellis Rowe '74 picked up the load. Klupchak was healthy as Dartmouth closed its season at Cornell and Princeton. He ran for 128 yards in a 17-0 win at Cornell. Needing 130 yards against Princeton, Klupchak got 154. His career total (1,788 yards) was a Dartmouth record for the next 16 years. His per-carry average of 6.0 yards is still a Dartmouth record. Said Crouthamel, "If Rick had been healthy, he'd have had the record long ago."

TOM CSATARI '74. In 1971, Tom Csatari was struggling as a linebacker. He moved to defensive end and won All-Ivy honors as a sophomore and as a junior. When the co-captain of the 1973 team earned the honor again as a senior, he became Dartmouth's first three-time All-Ivy first team player.

REGGIE WILLIAMS '76. In the defensive huddle at Harvard in 1973, Tom Csatari told Reggie Williams what he had been told by veteran teammates two years before: "Relax." Williams, a 6-foot 1-inch, 215-pound sophomore who was breaking into the starting lineup, relaxed but lost no intensity. From 1973–1975, he became Dartmouth's second three-time All-Ivy selection, and he was an All-American in 1975.

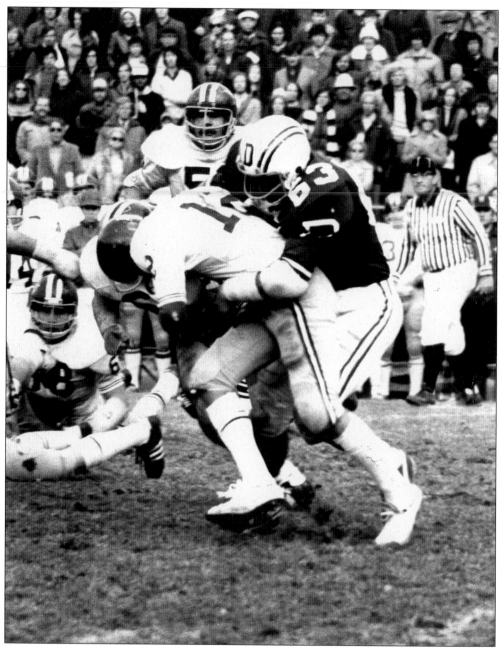

OVERPOWERING. This tackle of Harvard quarterback Milt Holt affirms that, as a raw force on the football field, there has never been a player at Dartmouth like Reggie Williams. He came to Hanover from Flint, Michigan, and over three seasons he set a Dartmouth record for unassisted tackles (243) that still stands. He assisted on 127 more, and his total of 370 is still the second-best record of all time. In 1975, Williams was the football co-captain and the Ivy League heavyweight wrestling champion. Selected by the Cincinnati Bengals in the third round of the 1976 NFL draft, Williams had a 14-year career with the Bengals that included Super Bowl appearances in 1982 and 1989. In 1987, *Sports Illustrated* selected him as co-sportsman of the year.

NICK LOWERY '78. Nick Lowery ranks fifth among Dartmouth's all-time kick-scoring leaders, but he is the only one who never missed an extra point—51 straight from 1975 to 1977. Lowery was a self-taught specialist whose drills included 40-minute daily exercises dribbling a soccer ball—"for dexterity of the feet." In 1977, he made two game-winning field goals. The first, a 40-yarder with two seconds to play, toppled Holy Cross 17-14 and earned him a ride to the locker room (above). Two weeks later, his 24-yarder produced the only points in a 3-0 win at Yale. Lowery's reputation as a kicker was really established after Dartmouth. He went on to an 18-year career in the NFL, 14 of them with the Kansas City Chiefs. Overall, Lowery's foot generated 1,711 points in the NFL. In 11 seasons, he did not miss an extra point.

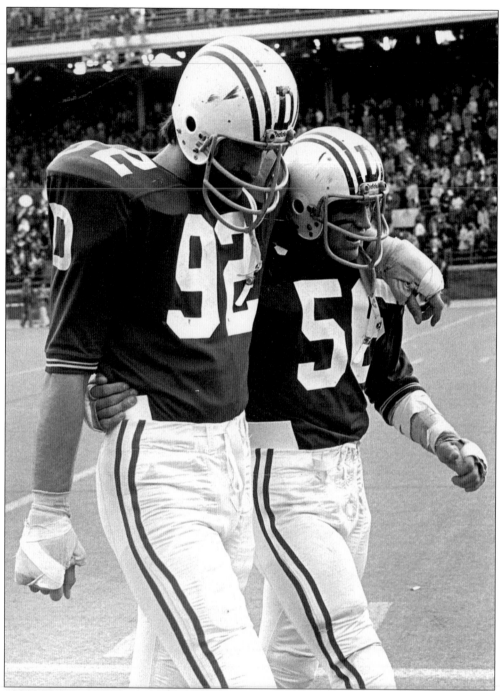

CLOSE, BUT. . . . After winning Ivy League titles from 1969 to 1973, Dartmouth was at the brink of earning another crown in 1977 but came up short. All-Ivy defensive tackle Gregg Robinson (92) and co-captain Jim Vailas, the middle linebacker, share the long walk at Franklin Field after Penn's 7-3 victory left Dartmouth the runner-up to Yale, a team the Green had beaten. A week earlier, Dartmouth had also lost to Brown 13-10. The Penn game was Jake Crouthamel's last as Dartmouth's coach. His teams had built a record of 41-20-2 over seven seasons.

MONA LISA. Jake Crouthamel's intensity as a player stayed with him as a coach. His coaching career ended in 1977. In 1978, he became director of athletics at Syracuse University, where he helped create the Big East Conference. He has also become one of the nation's most respected athletic administrators of the past quarter-century.

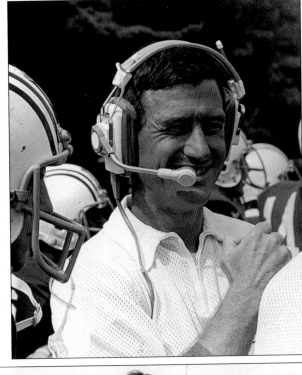

THE NEW YORK JETS. In May 1978, the New York Jets' rookie camp had a distinct Dartmouth flavor. Seen here are, from left to right, Nick Lowery '78, John Idzik, Gregg Robinson '78, and Ed Wisneski '72. Lowery was a free-agent place-kicking candidate who was cut in 1978, but he closed his career with the Jets from 1994 to 1996. Idzik, the offensive coordinator, was sending his son John '82 to Dartmouth that fall; the younger Idzik became an end. Defensive tackle Robinson, drafted in the sixth round, played for the Jets in 1978. Wisneski joined the Jets' public relations staff in 1977 and had a 10-year career with the Jets, NFL Creative Services, and the Philadelphia Eagles.

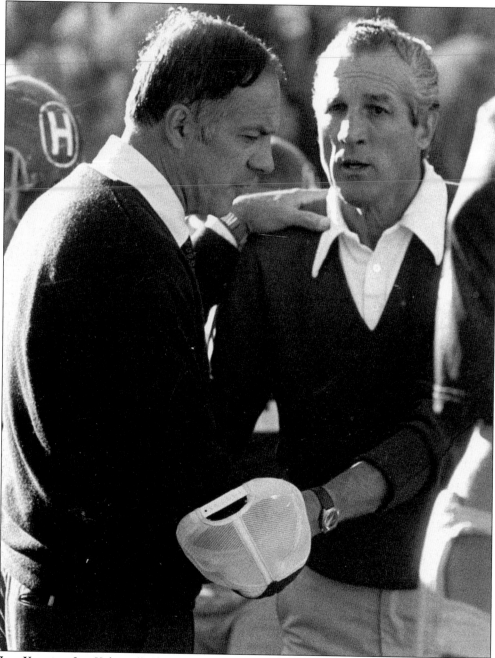

JOE YUKICA. Joe Yukica (left) returned to Dartmouth in 1978. His first team won the Ivy League title that had eluded the Green in 1977. His teams were also Ivy champs in 1981 and 1982. Yukica was a Bob Blackman assistant from 1961 to 1965, then had successful head coaching stops at New Hampshire and Boston College. The Penn State graduate guided Dartmouth until 1986. With Yukica is Joe Restic, who was introduced as Harvard's coach the same day that Jake Crouthamel was named Bob Blackman's successor. Restic led Harvard from 1971 to 1993. Over those 23 seasons, four Dartmouth coaches—Crouthamel, Yukica, Buddy Teevens, and John Lyons—built a narrow 11-10-2 advantage over Restic's teams.

JIMMIE LEE SOLOMON '78.
Recruited to Dartmouth by Ken
Weinbel, the track coach, Jimmie
Lee Solomon became a fleet
receiver on the football team and
an All-Ivy League sprinter. His
career after Dartmouth is more
impressive. A lawyer, Solomon
became an executive with Major
League Baseball in 1991. In 2003,
Sports Illustrated ranked him ninth
among the 101 most influential
minorities in sports.

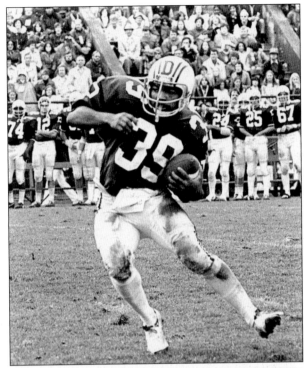

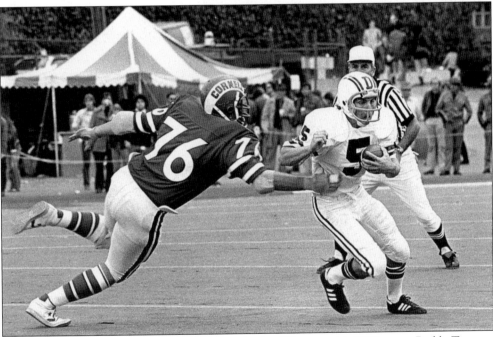

BUDDY TEEVENS '79. Co-captain and quarterback of Dartmouth's 1978 team, Buddy Teevens
passed for 1,396 yards as the Green won the Ivy League title with a 6-1 record. His energy as a
field leader earned him the Bushnell Cup as the Ivy League's outstanding player. A day after
the 1978 football season ended, Teevens was skating with Dartmouth's hockey team, which
took third place in the 1979 NCAA tournament.

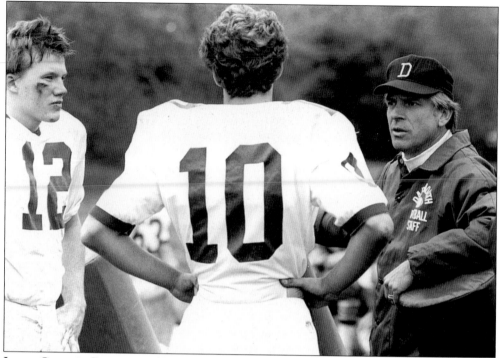

JOHN CURTIS. Everyone called him "Cactus." John Curtis came to Dartmouth as Bob Blackman's freshman team coach in 1965. With Jake Crouthamel, he coached the offensive backfield. He returned to the freshman team under Joe Yukica. When he retired from coaching in 1986, the question was, Did he teach his players more about football or about the enjoyment of fishing in New Hampshire's ponds and streams?

FRANK HERSHEY. Like John Curtis, Frank Hershey fell victim to cancer. Also like John Curtis, he was as much a confidante as a coach to countless Dartmouth players. From 1981 to 1986, Hershey coached receivers for Joe Yukica. An All-East player at Penn State, Hershey coached at Harvard from 1987 to 1994. He returned to Dartmouth and coached receivers under John Lyons until his death in 1998.

CO-CAPTAINS, 1980. Split end Dave Shula '81 (left) and linebacker Jerry Pierce '81 had All-Ivy seasons as Dartmouth's leaders in 1980. Shula grew up on the Miami Dolphins' sidelines as the son of NFL coaching legend Don Shula. He set Dartmouth season and career records for receiving yards (781 in 1980, 1,822 from 1978 to 1980) and career receptions (133). Pierce's total of 385 tackles (206 unassisted) broke the career record set by Reggie Williams from 1973 to 1975. His record still stands.

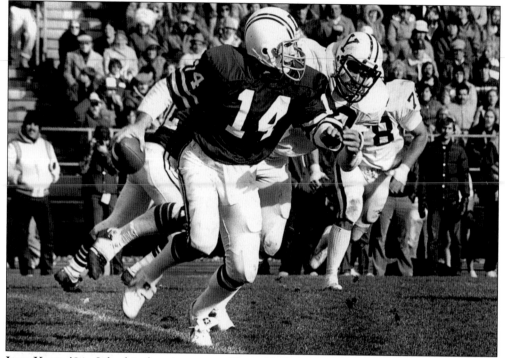

JEFF KEMP '81. Like his favorite target, Dave Shula, quarterback Jeff Kemp had an NFL pedigree, though he was too young to roam the sidelines when his father, Jack, quarterbacked the Buffalo Bills (1962–1969). But he still learned the game well. During the 1979 and 1980 seasons, Kemp passed for 2,385 yards. He then played with four different NFL teams from 1981 to 1991, passing for 6,230 yards.

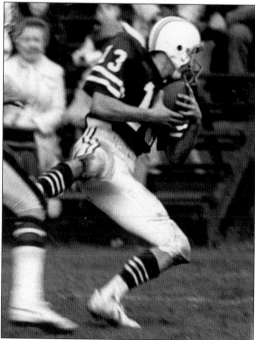

DAVE SHULA '81. Dave Shula's ability to make plays and his knowledge of the game took him to the NFL after Dartmouth. He played one season with the Baltimore Colts and then followed his father into coaching, including a stint as head coach of the Cincinnati Bengals. His son Dan '06 has followed his father to Dartmouth; he is a quarterback.

JERRY PIERCE '81. As a linebacker and nose guard, Jerry Pierce broke into Dartmouth's starting lineup as a sophomore and was Dartmouth's leading tackler in 1979 and 1980. He was named to the All-Ivy team in both seasons. He is shown here during the 1980 season with Norm Gerber, the Green's linebacker coach, who came with Joe Yukica from Boston College.

DAVE NESLUND '83. Co-captain of Dartmouth's 1982 team, Dave Neslund was an All-Ivy linebacker in 1982, making plays like this interception return for a decisive touchdown as Dartmouth defeated Brown 22-16 in the rain at Providence. The win helped Dartmouth defend the Ivy League title it had shared with Yale in 1981. In 1982, the Green joined Penn and Harvard as Ivy co-champions. Neslund is one of seven Dartmouth players with more than 300 career tackles (he had 321 from 1980 to 1982).

Jack Daly '84. By the time he graduated from Dartmouth, split end Jack Daly had gathered in far more yards with 135 catches (2,208) than the total population of his hometown, Peru, a dot on the map in northeast New York. During a career that saw him contribute to Ivy title seasons in 1981 and 1982, Daly broke all the records set by Dave Shula from 1978 to 1980. Daly scored 15 touchdowns from 1981 to 1983, another record, and his average yards per catch (16.4) remains the third-best career mark in Dartmouth football.

COACH BUDDY TEEVENS. Joe Yukica's departure (he coached the 1986 season after settling a contentious contract dispute with Dartmouth's administration) brought Buddy Teevens back to Hanover. The All-Ivy quarterback in 1978, he had been an assistant to former Dartmouth aides Jerry Berndt at DePauw and Rick Taylor at Boston University and had been head coach at Maine in 1985 and 1986. It took Teevens three seasons to turn the corner. In 1990, he brought the Green its first Ivy League title (shared with Cornell, which lost to Dartmouth) since 1982. Dartmouth repeated as outright champ in 1991. Teevens left a third title team in the making when he moved to Tulane in 1992. A decade later, Ted Leland, the athletic director who hired Teevens in 1987, was athletic director at Stanford—and hired Teevens again to coach the Cardinal.

CRAIG MORTON '89. "You do not see him move and suddenly he's by you" is how coach Buddy Teevens described wide receiver Craig Morton (25). As a sophomore in 1986, Morton and quarterback David Gabianelli '87 hooked up for the longest scoring play from scrimmage in Dartmouth history: 98 yards against Columbia. Dartmouth won only two games in 1987, as a preseason shoulder dislocation forced Morton to play with a strapped shoulder. He returned to form in 1988. With 138 catches from 1986 to 1988, Morton set the Dartmouth record for career reception yardage (2,605) and per-catch average (18.9 yards). Below, after a Saturday afternoon of football, Morton was up early on Sunday morning to play host to a Christian contemporary music program on Dartmouth's student radio station.

MARK JOHNSON '90. From 1987 to 1989, Mark Johnson passed for 4,413 yards, the third best all-time record at Dartmouth. Johnson was the quarterback who orchestrated an aerial game, unveiled by Buddy Teevens, that has led to a rewriting of the Dartmouth record book during the past 15 years. When he was not throwing footballs, Johnson was pitching for Dartmouth's baseball team, though he went on to a major-league career as a power-hitting first baseman with several teams.

DAVID CLARK '90. When Mark Johnson was not passing, David Clark was a prime weapon in Dartmouth's running game. Twice, against Harvard and Princeton in 1988, he broke record scoring runs of 97 yards. Against Penn in 1989, the 210-pound fullback carried the ball a record 51 times for 219 yards. Clark became Dartmouth's first back to gain over 1,000 yards in a season (1,063 in 1989), and his 1,812 career yards rushing is the second-best all-time record for the Green.

SHON PAGE '90. Records were made to be broken, and in 1990, fullback Shon Page, who had missed the 1988 season, eclipsed David Clark's season rushing record. Page gained 1,087 yards, a 5.0-yard average, but averaged nearly twice that when he set a record with 222 yards in 23 carries against Harvard. In 1990, when the Green won the Ivy League title, Page became the first of three straight Dartmouth players to win the Bushnell Cup as the Ivy League's outstanding player.

AL ROSIER '91. Al Rosier did not play in 1988, but he became Dartmouth's tailback in 1990 and 1991. He gained 723 yards behind Shon Page in 1990 and then became the Green's all-time rushing leader with his 1991 performance, which earned him the Bushnell Cup and All-America honors. Rosier set the single-game record with 229 yards (25 carries, 4 touchdowns) against Brown. His 1,432 yards is the season record, and his career total of 2,252 yards far surpassed Clark's record of 1,812 yards.

JOHN LYONS. After winning Ivy titles in 1990 and 1991, Buddy Teevens departed to Tulane. His successor was John Lyons, the Green's defensive coordinator since 1988. The Penn graduate picked up where Teevens had left off; Dartmouth shared the 1992 Ivy title with Princeton. The 2004 season is Lyons's 13th at Dartmouth. Only Bob Blackman (16 seasons) coached more Green teams. From 1992 to 1997, Lyons built a 44-15-1 record. The past six years have been a rebuilding period. Through 12 seasons, Lyons has an overall record of 59-59-1.

PAST AND PRESENT. An All-Ivy and All-East offensive tackle at Dartmouth in 1971, Joe Leslie '72 played on Ivy title teams from 1969 to 1971. He then began a career in coaching. While also earning two master's degrees, Leslie was an assistant coach at New Hampshire, Pennsylvania, and Boston University. He returned to Dartmouth in 1994 and coaches the Green's offensive line.

THE SPECIALISTS. Since 1990, three specialists have put their names in the Dartmouth record book. Placekicker Dennis Durkin '93 (1), an All-American in 1992, is the Green's all-time kick-scoring leader (202 points from 1990 to 1992). Wayne Schlobohm '00 (17) had a 40.2-yard punting record from 1996 to 1999. From 2000 to 2002, Alex Ware '03 (9) became Dartmouth's most recent three-time All-Ivy first team selection.

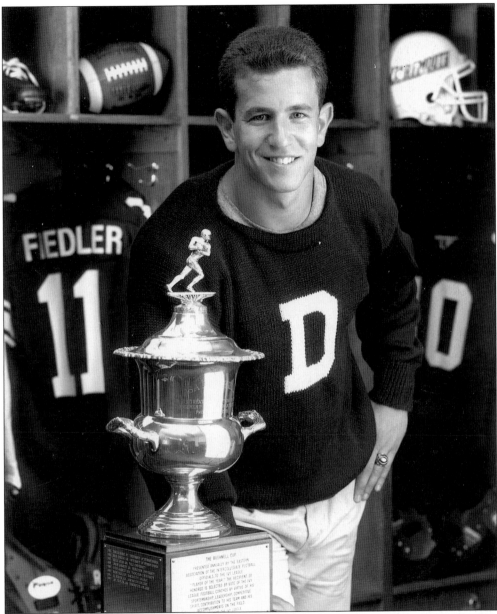

JAY FIEDLER '94. Jay Fiedler ranks with the greatest quarterbacks in Ivy League history. The only game that kept Dartmouth from winning three straight Ivy titles with Fiedler at the helm (from 1991 to 1993) was a 10-6 loss to Penn, the eventual champion, in the 1993 opener. He is shown above with the Bushnell Cup that he won as the league's outstanding player in 1992. Fiedler was a two-time All-Ivy choice and a third-team All-American in 1992. The 6-foot 3-inch, 220-pound signal caller from Long Island holds numerous Dartmouth records, including passing yards in a game (419 against Yale in 1992), career passing yards (6,684), and career total offense (7,249 yards). Fiedler has spent the past decade in the NFL. He saw limited service with Philadelphia, Minnesota, and Jacksonville before succeeding the legendary Dan Marino with the Miami Dolphins in 2000.

PASSING EXCELLENCE. During his Dartmouth career, Jay Fiedler threw a record 58 touchdown passes. He had five scoring passes during a 36-17 win over Penn in 1992. He had two four-touchdown games—against Harvard in 1991 and Yale in 1992. With Fiedler at the helm, Dartmouth's three-season record was 22-7-1.

COMEBACKS. In four of Dartmouth's last five games in 1993, Jay Fiedler engineered comeback victories for the Green. None was more impressive than his last game, against Princeton in swirling snow at Memorial Field. Trailing 22-8 with 9 minutes and 37 seconds to play, he ran for one score and passed for two more. His last touchdown pass was a 38-yarder to John Hyland '94 (24), who is greeted by David Shearer '95 (21). Dartmouth won 28-22.

A PERFECT TEN, 1996. At 185 pounds, 6-foot 1-inch Jon Aljancic '97 (19) was not cut in Jay Fiedler's mold—except as a field leader who knew how to win. The senior quarterback, taking a snap from center Dominic Lanza (62), completed 60 percent of his passes for 1,856 yards and 10 touchdowns. Aljancic also ran for 10 touchdowns, leading Dartmouth to an undefeated season, its first since 1970 and the Green's first 10-win season in history.

DOMINIC LANZA '98. A 6-foot 4-inch, 265-pound center, Dom Lanza was the "centerpiece" of Dartmouth's offensive line in 1996–1997, and Dartmouth won 18 of 20 games. Lanza was All-Ivy in 1997. More notably, the government major was an Academic All-American.

A CLOSE CALL. Zach Ellis '98 (24) was Dartmouth's leading receiver in 1996, averaging 19.5 yards with 32 catches for 623 yards. The All-Ivy wide receiver caught nine passes for 90 yards in the Green's opening game, a 24-22 victory over Penn that was won as Dartmouth scored with 19 seconds to play.

A VICTORY CELEBRATION. The perfect season was in Dartmouth's grasp in 1996. Here, fullback Pete Oberle '96 (32) is hoisted aloft by tight end Will Harper '98 (89). Oberle scored on a 32-yard pass from quarterback Jon Aljancic to give Dartmouth a 21-0 lead at Princeton. Dartmouth won 24-0 in the last game to be played at Palmer Stadium (dedicated by a Dartmouth-Princeton game in 1914 and replaced after the 1996 season).

UNDEFEATED CHAMPIONS, 1996. In the end zone at Princeton after Dartmouth's 1996 team had completed its 10-0-0 season, Brendan O'Neill '72, a member of Dartmouth's last undefeated team in 1970, reflected, "Were we a better team? Who knows and who really cares. We were a great team and now it's their turn to say they're the best." Dartmouth was one of three undefeated-untied teams in NCAA Division 1-AA in 1996. From 1995 to 1997, Dartmouth teams built a 25-4-1 record. The only blemish in a string of 22 games without a loss during this period was a 10-10 tie with Princeton in 1995. That tie was an incentive for Dartmouth in 1996; Princeton had kicked a field goal with four seconds to play. The deadlock clinched the Ivy League title for the Tigers.

LLOYD LEE '98. In 1996 and 1997, free safety Lloyd Lee was a two-time All-Ivy selection and an All-America second-team pick in 1996. Lee, who grew up near the Minnesota Vikings practice facility, shares the Dartmouth record for career interceptions (13). One came on this 70-yard scoring return against Princeton in 1996. Lee went on to play briefly in the NFL with the San Diego Chargers.

ZACK WALZ '98. From 1995 to 1997, Zack Walz was a three-time All-Ivy choice as a linebacker and a third-team All-American in 1997. He was drafted by the Arizona Cardinals and became a teammate and roommate to Pat Tillman, who walked away from pro football to serve with the U.S. Army. Tillman died in Afghanistan in 2004. With 356 tackles, Walz ranks behind only Jerry Pierce '81 and Reggie Williams '76 among Dartmouth's all-time leading tacklers.

CALEB MOORE '01. In 1999 and 2000, Caleb Moore, a 6-foot 4-inch, 305-pound guard from Wisconsin, became the first player at Dartmouth to be elected captain in successive years since halfback Jim Robertson in 1920 and 1921. He was a tri-captain in 1999, and in 2000 he was the first single captain since Jay Fiedler in 1993. Moore was a powerful and agile interior lineman, and his size reflects the changing scale of Ivy League players in recent years. Moore was twice named All-Ivy, and in 2000 he was a third-team All-American, even though he played on teams that struggled to win from 1998 to 2000, a dramatic downturn in fortunes after the Green's success from 1990 to 1996.

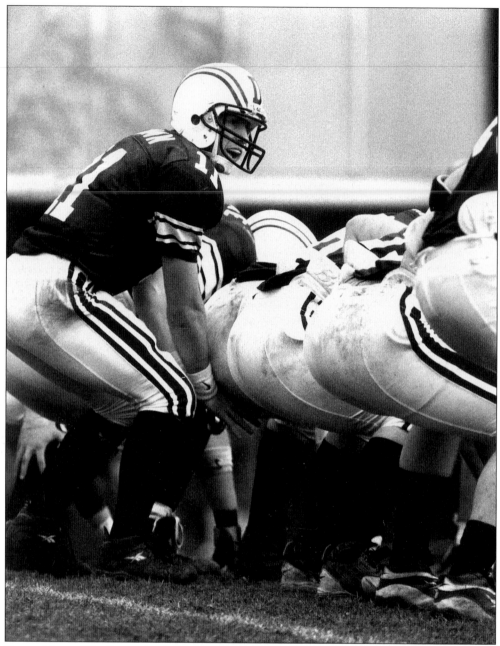

BRIAN MANN '02. Quarterback Brian Mann had passed for 2,999 yards from 1998 to 2000, but a broken hand kept him from playing in 2001. Mann was granted a fifth year of eligibility in 2002, and he put it to good use. He set a Dartmouth season record with 2,913 yards and 19 touchdowns in a season that saw the Green lose six of seven games by a frustrating total of 25 points. Dartmouth finished the season with a 3-7 record. During his career, Mann accounted for 5,912 yards passing, second only to Jay Fiedler '94, who had 6,684. Against Harvard in 2002, Mann set a Dartmouth single-game total offense record (440 yards, including 382 passing) en route to a season total offense record of 3,306 yards (2,913 passing). He accounted for 23 touchdowns in 2002, 19 by passing.